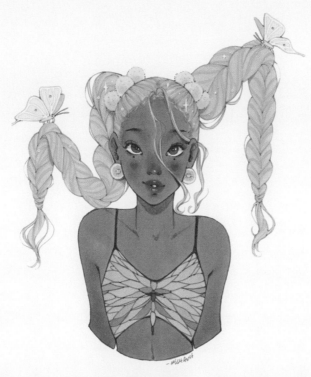

CHARACTER DRAWING
WITH ALCOHOL MARKERS

How to Draw MANGA-INSPIRED
Illustrations for Beginners

LIDIA CAMBÓN

Copyright © 2025 Lidia Cambón
Published by Blue Star Press
PO Box 8835, Bend, OR 97708
contact@bluestarpress.com | www.bluestarpress.com

Cover Design by Arctic Fever Creative Studio
Written and Illustrated by Lidia Cambón

Photography by Lidia Cambón (unless otherwise noted below)

Page 44 picture credits: Unsplash: woodear mushrooms © Guido
Blokker; mushrooms on mossy log © Jose P. Ortiz ; birds flying near
pink clouds © Kenrick Mills; white mushrooms © Phoenix Han; white
and brown flower © Juan Martin Lopez

Page 116 picture credits: Unsplash: flamingo © Gwen Weustink;
colorful architecture © Max Fuchs; pink rose © Heather McKean;
woman in black dress © Mikita Karasiou; pink butterfly © Katarzyna
Urbanek; birds in sky © Clément Falize

ISBN 9781958803349

Printed in China

10 9 8 7 6 5 4 3 2 1

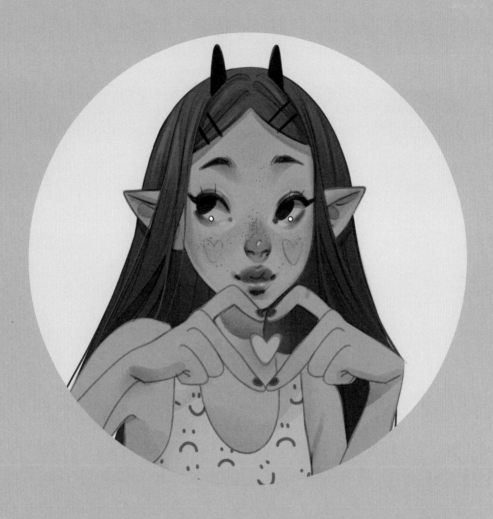

Dear reader,

Thank you so much for picking up this book and choosing me as your art teacher for the pages to come. In this book, I will show you everything I have learned about alcohol markers, the main tool I've used in the last few years to create my art. We will talk about character design and how I go about conceiving fantasy female characters for my ethereal illustrations. I hope you find it helpful and that this book brings you tons of inspiration.

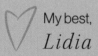 My best,
Lidia

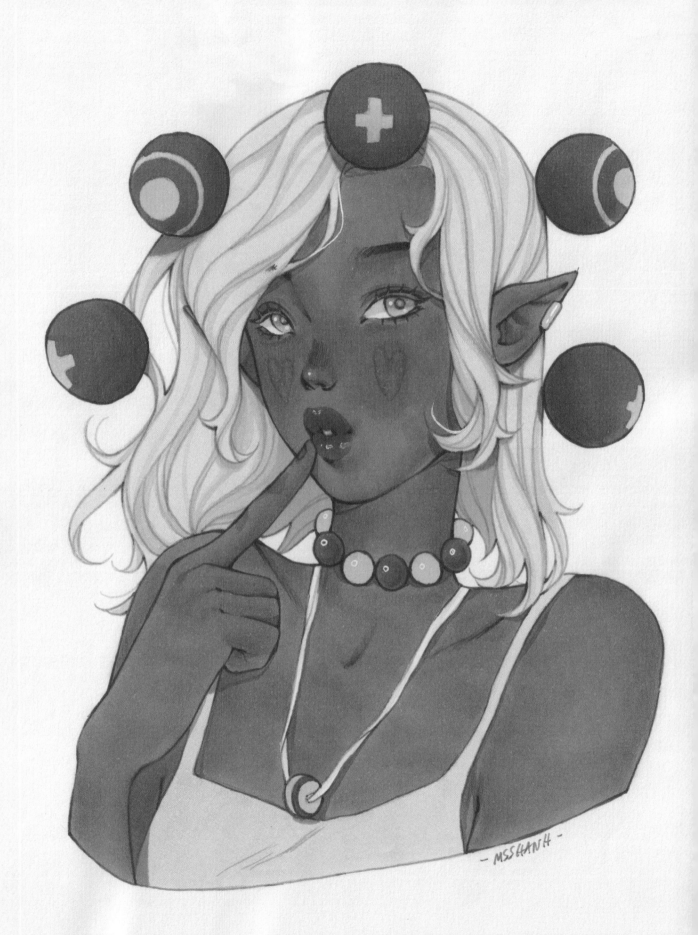

Contents

Introduction

Unlocking the World of Character Drawing
with Alcohol Markers

WELCOME TO THE COLORFUL WORLD of character drawing with alcohol markers!

Whether you're an aspiring artist eager to bring your imaginative characters to life, or simply fascinated by the vibrant art style often seen in anime and manga, this book is your guide to mastering this exciting medium.

Why Alcohol Markers?

I can't pinpoint exactly *when* art drew my attention. From a very early age, I was always drawn to the beauty in things; drawing and painting was just a way for me to channel those creative interests. Paper and pencil are always available, so they became my first mediums.

Seeing as I grew up a child of the nineties who watched loads of anime, I was inspired by the colorful and expressive characters in these cartoons. Subsequently, my first drawings were recreations of the characters in my favorite shows. I started by just copying the characters in my notebook with a pencil and trying to recreate their style, which was an easy way to get into drawing characters—what I still draw to this day. Looking back, it fascinates me to recognize how an interest that formed so long ago has so heavily influenced my current style.

While I started my lifelong love of art by drawing characters in pencil, I fell in love with color as soon as I had access to comics and magazines. The first coloring tools I got my hands on were some colored pencils—hard lead ones, of course. Inevitably, using these basic pencils proved to be a frustrating experience, and although the process was enough to make me realize that I wanted to start adding color to my art, it wasn't giving me the results I'd hoped for.

At the time, most of the color illustrations that I was inspired by came from the comic and manga covers I had in my collection of books, so the discovery of the millennia for me was when I learned what manga artists used to paint their beautiful manga covers: Copic markers. In hindsight, I marvel at the fact that I hadn't made the discovery before, but I hadn't had the right exposure. I didn't speak much English back then, and I still lived in the countryside of Spain, so it took me months to discover this around 2006.

Buying these markers online was out of the question for me at the time, but I eventually found a shop about one hour away from my house that sold Copic markers. As far as I knew, Copic markers were the only alcohol markers available then, and Copics were very expensive. At around eight euros a piece, I had to save money to buy five or six every month. Little by little, I procured myself a small collection of markers.

Learning to use them effectively was not easy; alcohol markers are not a very intuitive tool, and I had no resources to learn how to use them. I made them work through lots of experimenting and trying various approaches. Doing so gave me the tools to understand the methods that worked for me, and it propelled me to think outside the box in order to create unique results.

Since then, alcohol markers have never left my side. Even when I moved to London from Spain with very few items on me, I brought my small collection of alcohol markers. Fortunately, we now live in a time where endless colors of alcohol markers are available at many different price points, making them a medium that's readily available for almost anyone interested in experimenting with them. They are truly my favorite art supply, and I can't wait to share with you the tips and tricks I've learned from experimenting and illustrating with alcohol markers.

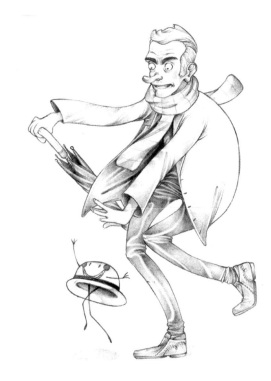

O BANCO DE METROCITY ESTÁ A SER ATACADO POLOS MONSTRUOS DA CARA SUCIA. COLOR... APARECE A ATACALOS COAS SÚAS PISTOLAS DE AUGA. COMO SON MOITOS, METROWOMAN DISPONSE A ENCENDER UN CIGARRO E A ALARMA ANTIINCENDIO E OS MONSTRUOS DISÓLVENSE.

1 — PLANO XERAL CONTRAPICADO DOS MONSTRUOS ENTRANDO NO BANCO E VENSE OS MONSTRUOS DE ESPALDA.

2 — PLANO XERAL CONTRAPICADO DOS MONSTRUOS ENTRANDO NO BANCO E VENSE DESDE ADENTRO DO BANCO.
"¡¡¡METROCITY ESTÁ A SER ATACADO POLOS CARASUCIOS!!!"

3 — PRIMEIRO PLANO DE UN CIDADÁ ANÓNIMO SENDO ATACADO.
"¡¡¡SOCORRO!!!"

4 — PRIMEIRO PLANO DAS BOTAS E METROWOMAN.
"PERO... ALGUÉN SE ACERCA."

5 — PLANO XERAL DE METROWOMAN.
"¡¡¡É METROWOMAN!!!"

6 — METROWOMAN DISPARANDO.
"ESTAMOS SALVADOS."

7 — PLANO PICADO CASI EXTREMO E VENSE MOITOS MONSTRUOS.
"¡HAI DEMASIADOS! ¡COLORWOMAN NON VAI A PODER CON TODOS ELES ELA SOLA!"

8 — PRIMEIRO PLANO DE METRO WOMAN CON CARA DE PREOCUPACIÓN. MISMO PLANO QUE O ANTERIOR PERO ENCENDENDO UN CIGARRO.

9 — VESE FUME E OS ASPERSORES DA ALARMA ANTIINCENDIOS ACENDENSE. CONTRAPICADO PARA QUE SE VEXA BEN.
"¡ALGO PASA!"
"¡METROWOMAN! ¡AQUÍ NON SE PODE FUMAR!"

10 — OS MONSTRUOS DISOLVÉNDOSE.
"¡MENUDA SORPRESA!"

11 — PRIMEIRO PLANO DE METROWOMAN RÍNDOSE CON SONRISA DE ANUNCIO. E OS MONSTRUOS DE FONDO DISOLVÉNDOSE.
"METROWOMAN TIÑAO TODO PENSADO."

12 — A CIDADE EN UNHA VISTA DE FONDO E EN PRIMEIRO PLANO O ALCALDE CHORANDO DE ALEGRÁ.
"¡GRACIAS METROWOMAN!"

o malete.

[Algo pasa!]

[Menuda sorpresa!]

(Metrowoman tiña todo pensado)

How to Use This Book

If you're looking for an introduction into the expansive world of alcohol markers and how you can use them to craft unique, expressive characters, you've come to the right place. **Chapter 1** will dive into all the supplies you'll need to get started with this book, as well as recommendations for a few extra supplies that can take your art to the next level. In **Chapters 2 and 3**, we'll start by exploring color theory and how to choose the best colors for your art pieces, and then we'll cover everything you need to know about blending with your alcohol markers so you can achieve the exact color, gradient, and look that you want. **Chapter 4** will cover the topic of artistic style as I walk you through my tips and tricks for developing your personal artistic style, so you can create your own distinctive characters.

Next, we'll practice putting our markers (and our drawing skills) to use. **Chapter 5** will teach you how to sketch the initial outline of your characters, so you can practice coloring them in with your alcohol markers in **Chapter 6**. In **Chapter 7,** we'll put everything we've learned so far into practice as I walk you through how to create a full character from scratch.

If at the end of your practice, you decide that you'd like to continue your art practice, **Chapters 8 and 9** will discuss the best ways to get your artwork in front of a large audience and grow your art community, as well as additional ways you can further continue your artistic education.

Finally, we've included twelve pages of practice paper at the back of the book, so you can practice using your alcohol markers on paper specifically intended to take this medium. However, you may benefit from having an additional sketchbook handy in case you want to continue practicing the art exercises in this book.

Whether you're a beginner or an experienced artist looking to expand your skillset, this book will provide you with the tools and inspiration to create captivating characters using alcohol markers. The included practice pages will allow you to put your newfound knowledge into action and witness your growth as an artist.

Happy drawing!

As I was learning, I created loads of sketches that I didn't share with the world. It was a good way to keep a safe space for my creativity and artistic experiments without the fear of judgment or the pressure of producing perfect art.

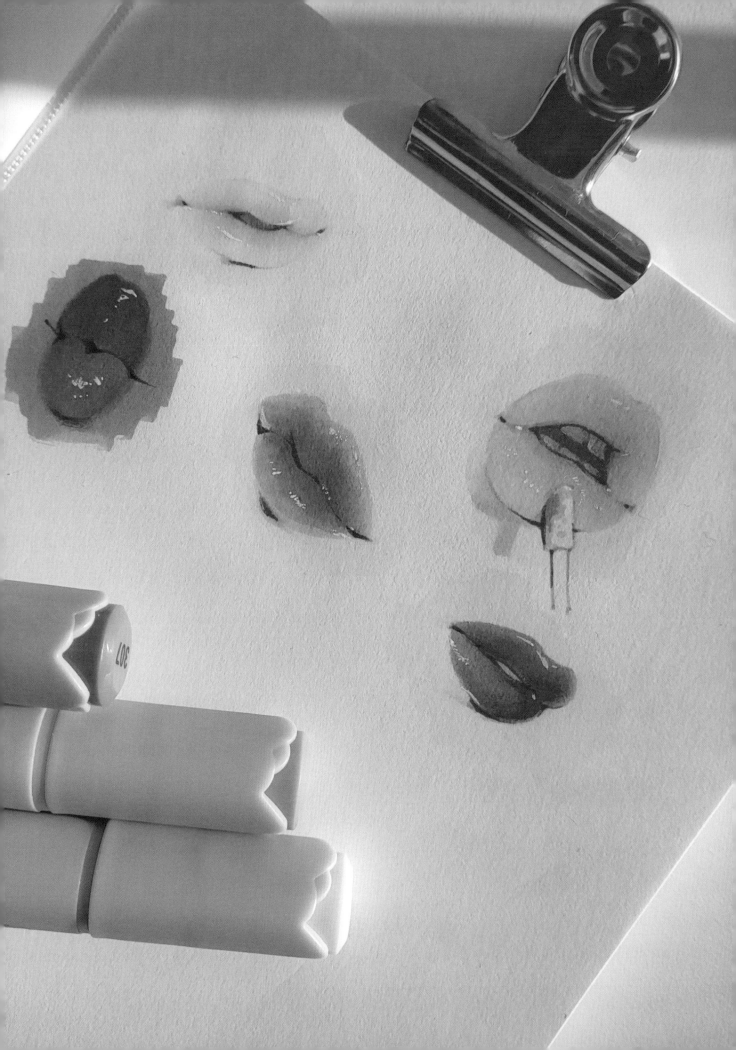

CHAPTER 1

Essential Tools

Building Your Alcohol Marker Toolkit

TO CREATE BEAUTIFUL CHARACTER ILLUSTRATIONS using alcohol markers, it's important to have the right supplies. Let's explore the different materials you might need as you get started on your alcohol marker journey, and a few extra supplies that might come in handy.

Alcohol Markers

BEFORE WE DIVE INTO MY LIST of recommended materials, I think it's important to first identify why I—and so many other artists—love using alcohol markers for our artwork.

First, alcohol markers are fast, easy to store, and versatile. Thanks to their blendability—as well as the wide range of colors available—any kind of color is possible, from moody darks to playful pastels. Alcohol markers can also give your artwork a digital-like finish, which can make it easy to photograph and scan your illustrations. You can also achieve different results, just by changing the type of paper you're working with—but more on that later!

As artists, we are fortunate that so many new companies have begun to manufacture alcohol markers, making them more accessible to everyone and available at many different price points. Because there are so many options out there, buying your first set can get a bit overwhelming, so this section focuses on the different brands and what you can expect from each.

Copic Markers

Copic is the original brand of alcohol markers. Copic began producing these markers back in the eighties, and they are still the most famous brand today, as they use great-quality ink and can manufacture any color under the sun—ranging from dark and saturated colors to soft and pastel shades. You can purchase them in packs, but every marker is also sold individually, which is convenient when you are interested in building your own collection of markers that go with your particular art style. They are refillable, so you can buy ink for the markers you use most often. You can also purchase replacement nibs. Copic offers their own paper and other accessories for their markers, too.

Overall, the Copic brand offers a comprehensive ecosystem of products that optimize work, so there's no wonder why they are the industry standard. When purchasing, though, bear in mind that not every Copic marker is the same as they offer different types of nibs (round, chisel, and brush), so take care in selecting the right options for you.

These markers are one of, if not the most, expensive choices on the market, but the price comes with excellent quality.

If you can, I recommend trying them at least once, though I don't recommend these markers for someone who is just starting out. Selecting a more affordable option until you get used to the medium and understand what you need your markers to offer will benefit you cost-wise. In addition, the brush nib from Copic markers is very soft, which means that although you can achieve amazing results and line variation, it is also difficult to use for someone with limited experience, which can lead to frustration. If you already have experience with cheaper marker brands, give Copic a try. They could help level up your coloring game!

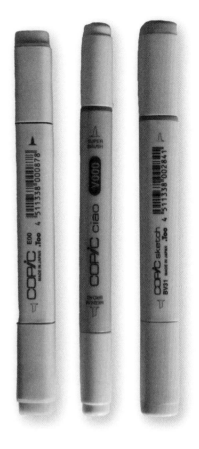

Markers as pictured above, from left to right: Copic Classic E00, Copic Ciao V000, and Copic Sketch BV31

Winsor & Newton Promarkers, Spectrum Noir, and Other Premium Brands

Some professional, established brands also offer alcohol markers, the most famous of them being Winsor & Newton with their Promarker line. The ink quality and the color selection are similar to those offered by Copic, so sometimes the choice comes down to personal preference. Promarkers are often used for fashion and architecture design, as the grip offered by these markers differs from Copic, which in my opinion is better for more organic designs. These could be a good option for you if you are ready for a professional-quality marker and Copics aren't available to you.

Top right of next page: Two types of Promarker: the Classique and the Promarker Brush.

Arrtx, Ohuhu, and Other Cheaper Alternatives

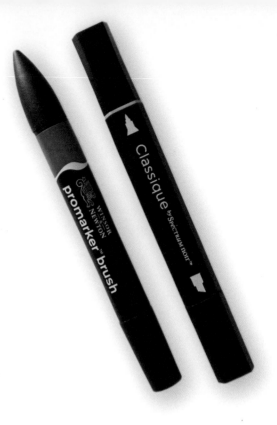

In recent years, new brands of alcohol markers have appeared on the market, making growing a larger collection of colors finally possible for those of us on tighter budgets. Of course, the quality is not as always equal to their more expensive counterparts, but unlike other media like watercolors or acrylics, you can achieve more professional results with these markers if you know how to make the most of them.

These markers usually come in big packs so you can't buy the markers individually. Most of these brands also don't offer refills. The range of colors is getting bigger every day, but because they don't sell individual markers, you might have to buy a big pack even if you are only interested in a couple of the colors. When holding these markers in hand, you can feel that the build is not as high-quality compared to higher-end brands like Copic. Still, I've never felt that this has held me back from getting good results; rather, it is just a cosmetic difference that doesn't affect performance.

Because the quality of the ink is surprising for the price, these are the markers I use the most. I recommend these markers for beginners but also to those for whom having a big collection of different colors is important. Because they are inexpensive, they are the best way for you to start your marker collection and try out this beautiful medium.

When buying from these brands, keep in mind that because they are relatively new, they have gone through many iterations, so keep an eye out for the latest versions of their products. That way, you can make sure to avoid any of the problems that early versions of these markers had. Nowadays, most of them come with the combo of chisel nib and brush nib—but once again, I offer a word of caution to double-check that you're purchasing the most recent versions, as the early versions used to be round nib and chisel nib and that might not be what you want.

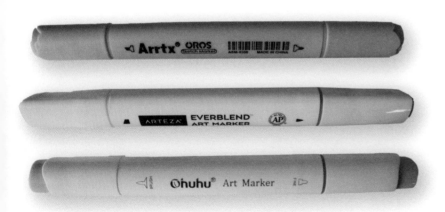

From top to bottom: A marker from the Arrtx OROS collection, an Arteza EverBlend art marker, and an Ohuhu dual-tip marker from their Honolulu collection.

All About Nibs

The importance of nibs can often go overlooked, but the type of nib you choose for each part of your project can have a big impact on your process. There are three main types of nib: brush, chisel, and round. Let's go over the pros and cons of each type of nib, as well as my recommendations for when to use each one.

BRUSH NIB

CHISEL NIB

ROUND NIB

Brush Nib

As one of the most popular types of nibs, a brush nib is very useful when it comes to blending, as well as for painting areas like hair and skin. I've noticed that there tends to be two main kinds of brush nibs, which I'll call soft brush nibs and hard brush nibs.

Soft brush nibs are very flexible and allow for more control over the pressure placed onto the paper, which helps determine the thickness of lines. Because of this nib's flexibility and bounciness, I love to use soft brush nibs for adding highlights to hair, but I don't recommend using this nib for filling in large areas of color, as it will cause patchiness and prevent you from getting a perfect flat.

Hard brush nibs release ink faster than soft brush nibs, which can bleed through your paper if kept in the same spot for too long. This nib is still flexible, although not as flexible as a soft brush nib. Hard brush nibs are better for filling in large areas of flat color and are great for beginners who may not yet feel comfortable using soft brush nibs.

While brush nibs are really popular, they can often be overused—so be careful not to use brush nibs in areas where another nib may be better!

Chisel Nib

A chisel nib is a very versatile nib, and one of my favorites! Chisel nibs are relatively consistent in the amount of ink they release, which makes them perfect for filling in big areas and achieving perfect flat colors. Because of their unique shape, chisel nibs can be used for large sections as well as small details, but they're not the best choice for blending or creating flawless gradients.

Round Nib

Also known as bullet nibs, round nibs come in slightly different sizes depending on the brand, but they are typically small, pointy nibs that allow for a lot of control. Round nibs are perfect for drawing thin lines and minor details, but they can also be used for filling in small areas when held at an angle. Be careful: this nib can cause patchiness when used to fill in larger areas, although it's a great choice for artists whose style is flat and graphic!

Let's practice working with the different types of nibs and the main brushstrokes you'll use for each. This will not only help you gain confidence when laying down color with your markers, but it will also help you learn which nibs are best to use for different areas of your illustrations. Flip to the blank practice paper in the back of the book or grab your sketchbook to practice these exercises!

Brush Nib

Although it's a very valuable nib, the brush nib can be a difficult one to learn how to control, so I recommend spending some extra practice time with it so you can become familiar with how it paints.

Side note: The brush nib can change between brands, so you may find it easier or more difficult depending on the brand of marker you're using.

Brush Nib 1: Start by practicing a perfect, straightforward line. Using the side of the brush nib, drag the marker in one direction, making sure to maintain a consistent speed and pressure.

Brush Nib 2: Then, repeat this action but only use the very tip of the brush nib and with very light pressure. Just like the brushstroke we practiced for Brush Nib 1, the key is to keep the same pressure and speed to get a perfect line, but now it's a bit more difficult! Practice this until you achieve a continuous perfect line that is free from any breaks or skips.

Brush Nib 3: Next, practice controlling the pressure and direction by drawing a wavy line. Use light pressure on the upward brushstrokes to achieve thinner lines, and switch to heavier pressure on the downward brushstrokes to get thicker lines.

Brush Nib 4: This brushstroke, which involves quickly moving from heavier pressure to lighter pressure, can be very useful when creating gradients and shadows. Practice creating these lines very quickly. You should not only see a difference in the thickness of the line as you change the pressure, but also in the ink flow, which will make the thicker part look darker and the thinner part look lighter. This is a very important exercise and one that can create very different results depending on the brand of the marker and how hard the brush nib is, so I recommend you try this exercise with each brand you own so you can see the differences for yourself.

BRUSH NIB 1 BRUSH NIB 2 BRUSH NIB 3

BRUSH NIB 4

Chisel Nib

Chisel Nib 1: Since the chisel nib is so useful for filling in large areas, let's practice by first drawing a thick, straight line. Use the entirety of the flat edge of the nib and drag the marker in a continuous line, only moving in a single direction. The aim is to work fast enough so you avoid leaving dark streaks without going back to areas you've already worked on, as this can create unwanted ink lines.

Chisel Nib 2: Use the side of the chisel nib to create a fine line. Make sure to always use the same amount of pressure and speed to keep the ink flow consistent. You will often use the chisel nib for background areas, so it's important to know how to fill in smaller details without changing your nib so the background color stays flat and consistent.

Chisel Nib 3: Practice using the side of the chisel nib again, but instead draw a wavy line. Rather than using a different amount of pressure for the upward strokes and downward strokes, keep your pressure consistent so you achieve a wavy line that has the same thickness throughout.

CHISEL NIB 1 CHISEL NIB 2 CHISEL NIB 3

Round Nib

One of the easiest nibs to use, the round nib is great for achieving perfect lines with a consistent color and thickness. For this reason, you should learn how to master this nib, as it can become your best friend for painting details like hair.

Round Nib 1: Practice creating uniformly straight lines with your round nib. You'll notice that this nib offers very little difference in the ink flow, no matter how much pressure you use.

Round Nib 2: Now, test out wavy lines, noticing how the ink flow remains relatively steady between upward and downward brushstrokes.

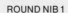

ROUND NIB 1

ROUND NIB 2

Papers and Sketchbooks

As mentioned before, a fascinating and often overlooked property of alcohol markers is that they can look vastly different depending on the paper you use. The paper or sketchbook you choose will impact the level of saturation, the actual color, and the blendability of the markers, as well as how much the ink will spread and the final texture of the drawing.

It's important to experiment with different types of paper until you find the one that works for your style. There's no right or wrong choice, just the one that works for you.

Now let me tell you a bit more about some of the different papers that you can find, both in sketchbook and loose-sheet format. You can look to this as a guide when determining where to start, depending on what you are looking for.

For each paper, we will discuss the following chief qualities:

- **Blendability:** How easy is it to blend different colors together? Will it allow you to get perfect flats that don't look streaky? How easy is it to achieve a good gradient?

- **Absorbency:** How much ink does the paper absorb, and how quickly?

- **Bleed-Proof:** Does the paper prevent ink from bleeding onto other pages?

- **Ink Spread:** Once you put down color, does the ink stay contained to the area you painted? Or does it start spreading beyond that boundary?

- **Compatibility with Other Media:** How easily does the paper take other art supplies—whether wet or dry media—in addition to the alcohol markers?

- **Price:** How affordable is the paper compared to other options on the market?

- **Availability:** How easy is it to find this type of paper in stores?

Alcohol Marker Paper

Blendability:	Medium-high
Absorbency:	Medium
Bleed-Proof:	Yes
Ink Spread:	Low
Compatibility with Other Media:	Only dry media
Price:	Mid-tier
Availability:	Widely available online; difficult to find in stores

Let's start with paper marketed as alcohol marker paper. This type of paper has become more available in recent years, and most marker brands offer this paper, as it's engineered for optimal results with their own markers.

This type of paper is normally bleed-proof, meaning that the ink won't transfer to the other side of the paper.

This is one of the safest options to choose from, and I recommend it if you are starting out and you don't want to worry too much about how the paper you are drawing on will impact the performance of the markers you're using. With alcohol marker paper, you can be precise because the ink won't spread too much, and you don't need to worry about the ink bleeding onto the next page. This paper also takes other dry media well (other inks, colored pencils, etc.).

However, this paper is typically thin and can be a bit fragile to work with. Although it's gained popularity in recent years, it can still be difficult to find in stores and isn't available in many sizes. It also tends to be more expensive than other options. Nevertheless, if you find a brand of alcohol markers that you love, it may be worth experimenting with their paper to see how you like it.

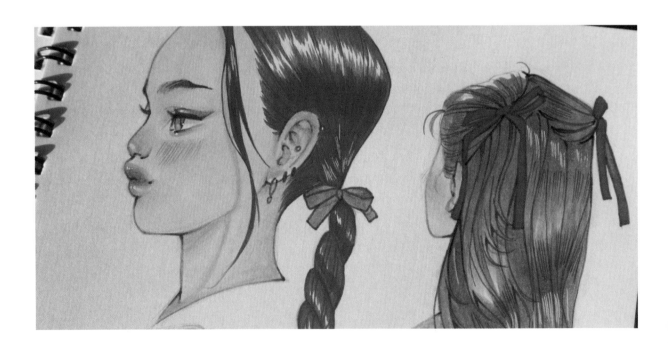

Mixed Media Paper

Blendability:	Low
Absorbency:	Medium-high
Bleed-Proof:	No
Ink Spread:	Medium
Compatibility with Other Media:	Compatible with most wet and dry media
Price:	Affordable
Availability:	Widely available online and offline

This is an option many people consider when starting with alcohol markers. This paper is a little bit thicker; it gives more texture, which some people desire for their work; it's incredibly easy to find in any art store; and it comes in all different sizes and formats.

However, in my own art, I've found this paper very difficult to work with. This doesn't mean that it's a bad option for you. In fact, you might already have some of this paper in your collection, so it's always worth trying out.

Because it is a bit thicker, this paper absorbs a fair bit of ink, and it dries quickly. This normally makes blending more difficult, so the color often starts looking streaky quickly unless your technique is perfect. Because of this, it can spread a little, too, which makes precision in drawing rather challenging. Most of the time, this paper is not thick enough to contain the ink, so it will often bleed onto the next page.

On the positive side, this paper takes very well to other media, both dry and wet. So, depending on your process, this could be a worthy option for you.

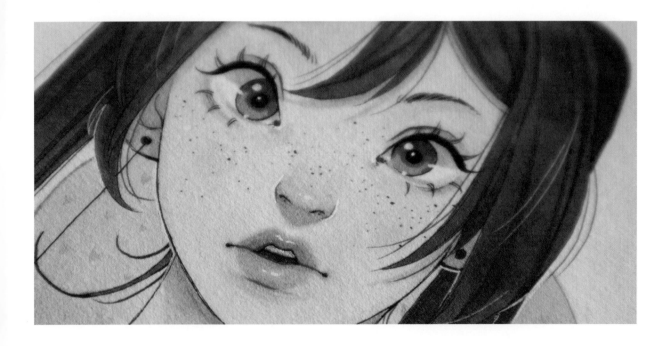

Watercolor Paper

Blendability:	High
Absorbency:	High
Bleed-Proof:	No
Ink Spread:	High
Compatibility with Other Media:	Highly compatible with wet media; can be tricky with dry media
Price:	Expensive
Availability:	Widely available online and offline

This is an intriguing type of paper—the possible results from using it can be quite different compared to using any of the other papers mentioned in this section. Watercolor paper is very thick and it comes in a few different textures, the most popular of which range from a very textured version (what is known as "cold press") to a smoother but still textured version (known as "hot press"). It also comes in different compositions—cotton or cellulose. But we will focus on the main properties of this paper that apply to any variant.

One of the main properties of this paper that we benefit from when using alcohol markers is its high blendability. Watercolor paper is perfect for illustrations that use many different colors and gradients, but it's not recommended for illustrations that feature large areas of solid color, as it can be difficult to get a homogeneous flat color.

The trade-off is that there will be loads of ink spread, which makes being precise more challenging. For this reason, if you choose this paper, I recommend working on a larger size of paper than what you would normally go for, to allow room for error.

Even though this paper is thick, it can still bleed to other pages, especially if you color many layers or work on saturated areas, so make sure to be careful.

However, watercolor paper is a splendid option if you want to add any kind of wet media to your illustration; it will take other inks, watercolors, and gouache perfectly! But be careful with colored pencils if your paper is heavily textured—the texture of the paper will show through the color, preventing your piece from looking seamless.

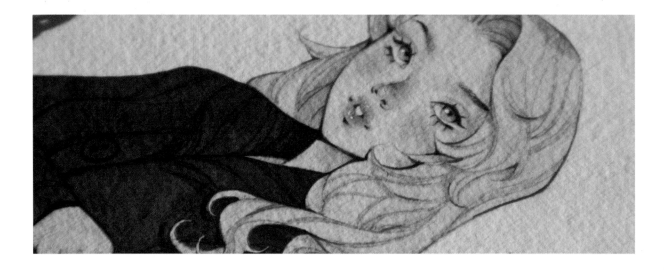

Fountain Pen Paper

Blendability:	High
Absorbency:	Low
Bleed-Proof:	No
Ink Spread:	Low
Compatibility with Other Media	Only compatible with dry media
Price:	Expensive
Availability:	Mostly only available online

Paper traditionally marketed to be used with fountain pens can be tricky to find, but strangely enough, I find that it usually works extremely well with alcohol markers. It offers qualities that are in between those of watercolor paper and alcohol marker paper.

Most times this paper is on the thinner side, but it's very resistant to tears caused by continuous erasing, which can be helpful for your process, especially if you sketch straight onto the paper. Other papers, like watercolor paper, will suffer from continuous erasing, but I've never had a problem erasing a lot on fountain pen paper.

This paper offers minimal spread, which makes it very easy to be precise. This means you can work on smaller sizes of paper and more easily achieve small details. I find this paper great for when you need to create perfect flats, so it's fantastic for any style where you want to achieve a digital-like look—like anime or cartoon styles—which mainly utilize flat colors.

Fountain pen paper works well with colored pencils, fineliners, and other ink pens, but it bulges with wet media, so you will need to be careful. It's also thin and can bleed significantly onto other pages, so make sure to use an extra piece of paper in between pages to avoid transfer.

This is my personal favorite paper and the one I use for most of my illustrations. Generally, it's not only difficult to find, but it's also more expensive than other options. For this reason, I recommend this paper to anyone who already has some experience with alcohol markers and wants to upgrade from alcohol marker paper and try something new.

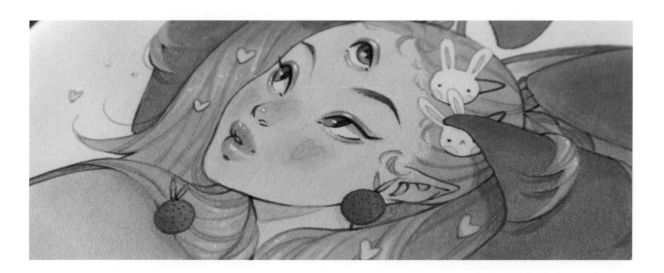

As you can see, the results across different papers are varied. It's important to choose a paper type that works best for your style to avoid frustrations and to prevent your experience drawing from becoming more difficult than it needs to be. This enables you to focus 100 percent on your illustrations with no limitations.

This is only a small list of papers based on my personal experience and the most common types of paper available. I encourage you to try as many papers as possible, including others not listed here that you find. Sometimes the type of paper you use can have a bigger impact on the result than the markers you use, and knowing which paper is best for you will benefit your art journey greatly.

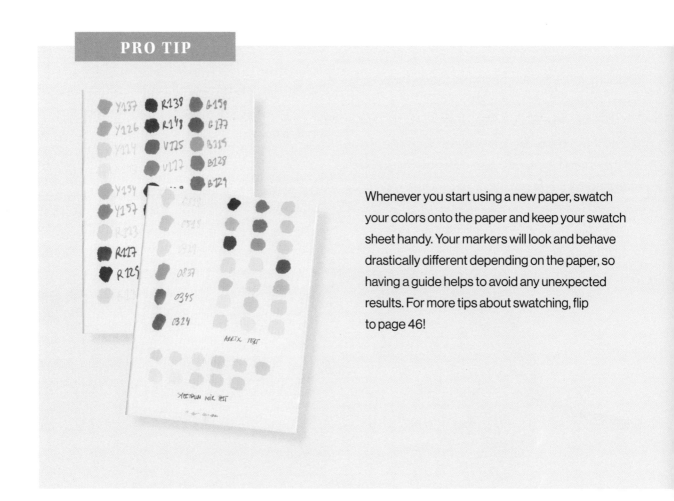

PRO TIP

Whenever you start using a new paper, swatch your colors onto the paper and keep your swatch sheet handy. Your markers will look and behave drastically different depending on the paper, so having a guide helps to avoid any unexpected results. For more tips about swatching, flip to page 46!

Line Art Supplies

If you've ever watched an illustrator complete a piece from start to finish, you may have noticed how transformative line art can be during the final stages of the process. Once the base colors are down, line art adds dimension and can make an illustration finally come to life.

Line work can completely change the look of an illustration—it is as important of a step as any other—so pay special attention to this particular art supply. There are too many brands to list here, but hopefully this guide will help you choose the best option for you.

Let's have a look at the qualities you should be looking for, depending on your illustration style.

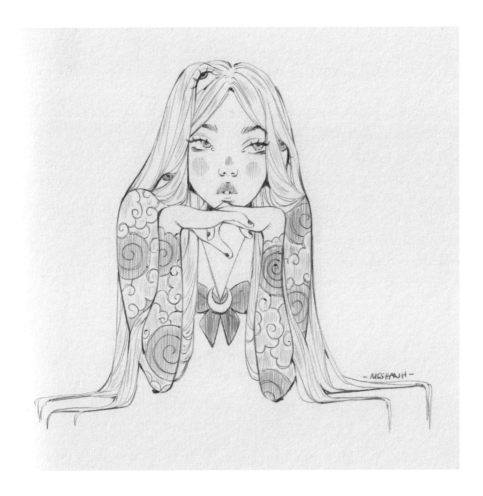

Although there are many supplies you can use to create detailed character illustrations, I'm a big fan of everyday tools that can be used for art. A ballpoint pen is a great tool for sketching and is still one of my favorites to this day.

Compatibility

It's important that the formula of the ink you choose is compatible with the supplies that you use for your illustrations. When using it in conjunction with alcohol markers, you want to choose an ink that doesn't smudge with these markers. If you are going to add any wet media to your illustration, you also need to make sure that your ink is water-resistant.

To properly test your inks, it's important that you allow enough time for them to fully dry out, as most inks will bleed and smudge before they are fully dry.

Opacity

Some inks come out a little transparent, while others are fully opaque. Inks that are on the transparent side are better for soft and realistic art styles. They also allow you to build up opacity by adding layers. Opaque inks are great for bold and graphic styles that require more precision and greater color payoff.

Nibs and Nib Thickness

There are loads of options to choose from in this category, with varied effects. For instance, a fountain pen will offer a great variety of nibs for you to explore. These are great if you want your lines to vary in thickness. However, the easiest and most utilized option for illustrations is fineliners, which come in a variety of sizes and colors. They are also very convenient to use. It is difficult to get thickness variation in your lines, but you can achieve some with practice.

If you work in a bigger format or your style is bold and graphic, opt for a thicker fineliner. On the other hand, if you work on smaller-sized paper or have a very delicate style, I recommend you consider smaller-sized fineliners (as small as 0.05).

Color

If you are looking for a more traditional style to your art, opt for pure black fineliners. If you want a more dynamic or realistic style, consider trying colored fineliners.

Colored fineliners are easy to find, and they could be a great addition to your illustrations if you feel that your work comes out looking a bit flat, or if you just want to change things up a little bit. Lines could be multicolored or monochromatic— both options offer a very different look.

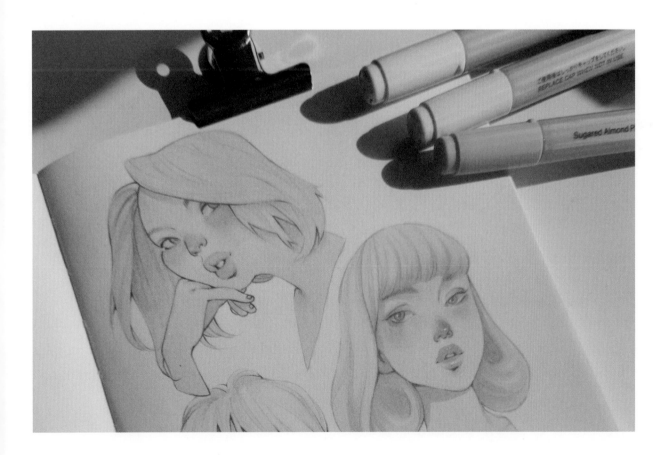

When it comes to choosing the right color of fineliner for a piece, there are a few different methods I like to use, depending on the look I'm going for. Of course, you can always use a black fineliner to add drama and heavy accents to your illustration, but this tip will focus on colored fineliners and the different ways you can use them to your advantage.

The "Moody Line Art" Method

When I want an illustration to have a moody feel, I opt for a monochromatic color palette. Whether it's a piece that has a very warm color palette, a very cold color palette, or combines many shades of the same color, choosing a similarly colored fineliner can really enhance the mood of the piece. For example, if I'm creating an illustration that has a warm color palette and I want to give it a moody feel, I'll use one warm-colored fineliner (like orange, red, or another warm earth tone) for the entire piece.

The Color-Matching Method

This method is just as it sounds; it's all about matching the color of your line art with the color of the specific area you're adding detail to. Because of this, the color-matching method can require you to have a wide variety of colored fineliners to choose from, which may not be as feasible for beginners. Still, this is a very popular method for line art. Just make sure you have a fineliner that's a slightly darker color than the area you're lining.

A Mix of the Two

There are times when I want to include more than just one value across an entire illustration, but I also don't want to use too many colors and distract from the overall message of the piece. In these instances, I'll combine the two methods above and use a selection of two or three fineliner colors, including an accent color. I find that this helps create a bit of interest when I want my illustration to have a softer, more subtle look.

If you're interested in learning more about color theory and the strategies I use when choosing colors, we'll dive more into color in Chapter 2!

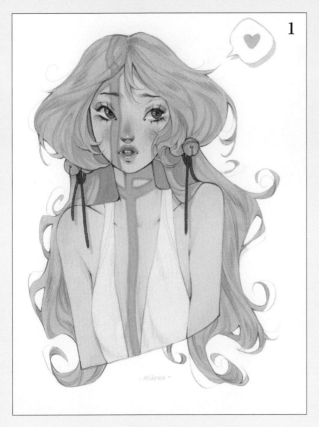

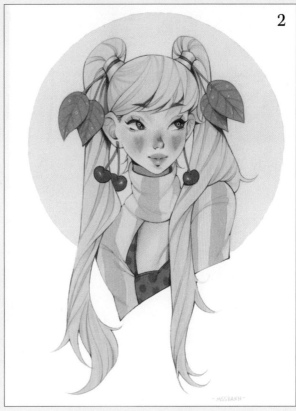

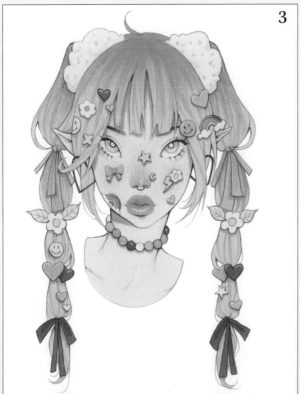

1. **Moody Line Art Method:** For this illustration, I primarily used reds throughout the line art and only added some darker colors around the eyes and face to bring dimension to these areas. When choosing the darker colors, I picked colors with warm, reddish-tones to match the rest of the piece.

2. **Color-Matching Method:** There are two very prevalent colors in this illustration—green and red—and the contrast is what makes it interesting, so I made sure to use matching line art in each area to enhance the contrast.

3. **Mix of the Two:** In this illustration, the tone is pretty monochromatic but I've included a few contrasting elements to add some interest. For this type of piece, I like to use a different colored liner to outline those elements so they stand out.

Extra Supplies

You can complete a full illustration using only alcohol markers, but using other art supplies in tandem can truly bring your illustration to the next level. I've compiled a list of some of the extra supplies I use for my illustrations. These help me elevate the look of my characters and achieve effects that are difficult to obtain solely with alcohol markers.

Colored Pencils

Colored pencils are my main ally, and I use them in combination with alcohol markers all of the time. They are great for creating a base sketch if you want to avoid the muddy color that sometimes results from graphite pencil. I also use them to add subtle bits of color over the top of markers, as they are easy to blend. You can use very thin layers to achieve the smallest bit of color.

My go-tos are the erasable colored pencils, so I can experiment with adding bits of color and not worrying about permanence. I also recommend investing in a blending stick, which will allow you to more easily blend your colored pencils and avoid a streaky look.

If you don't already have colored pencils, I'd recommend getting at least a 12-pack so you can have the essentials, like black, brown, and white, as well as one of each color in the rainbow.

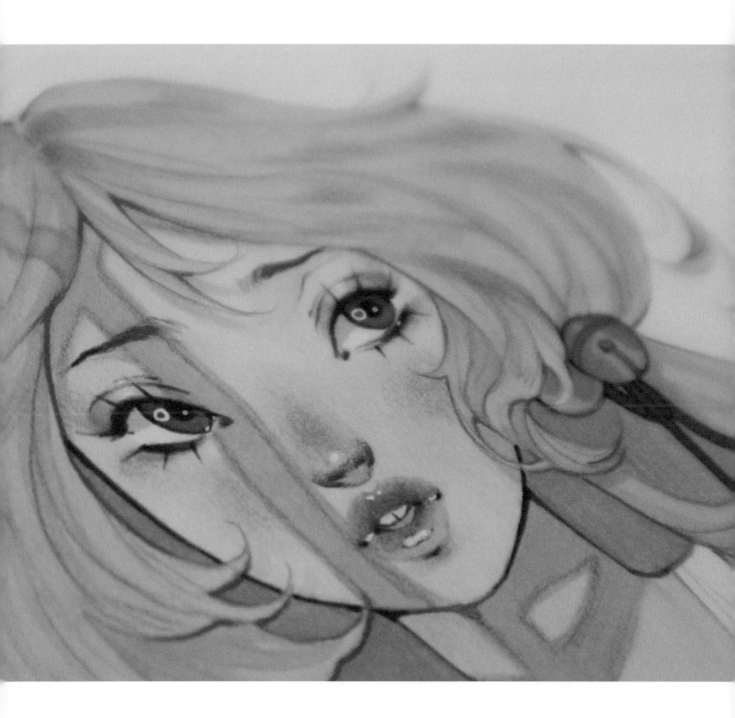

In this illustration, I used colored pencils for the line art and other small details. Because colored pencils are not as pigmented and harsh as ink pens and markers, I was able to achieve a very soft line art, which was exactly what I wanted for this character.

For this illustration, I added loads of little details in gouache. Because of the opaque nature of these paints, I didn't have to worry about the gouache showing up against the darker colors.

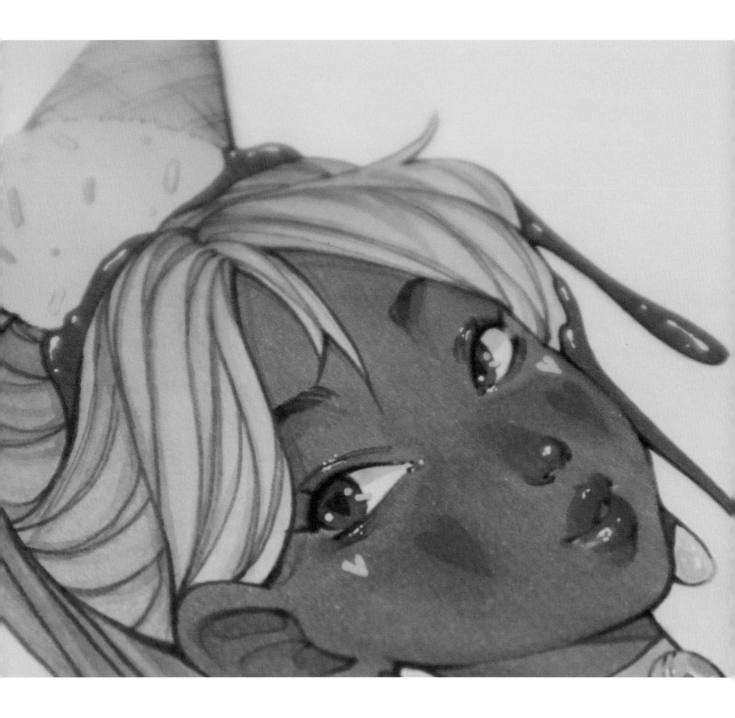

Gouache

Another great addition to marker illustrations is gouache paints. Both traditional gouache and acrylic are good options.

Gouache is fully opaque, which is a quality that alcohol markers lack. That is why gouache is the perfect companion to alcohol markers—gouache is perfect for adding highlights, overlaying graphic elements, including little details, and even making corrections!

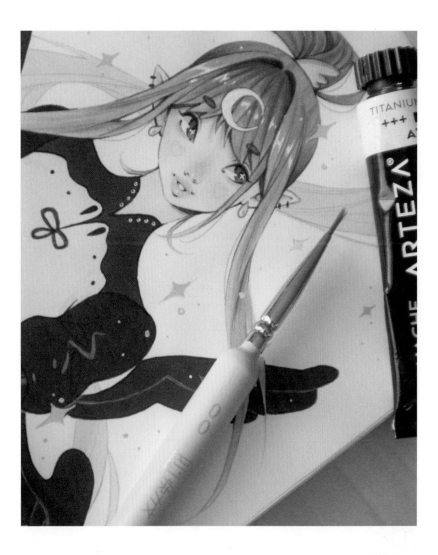

Paint Markers

Paint markers are very similar to gouache but come in pen format, which can be more convenient as they allow for more precision. They are my go-to for small details and eye highlights.

Masking Fluid

This supply is mostly used with watercolors, but you can achieve some cool effects by using it with alcohol markers. Masking liquid can be useful when you need to do a color overlay and want to be precise with the areas you don't want to cover.

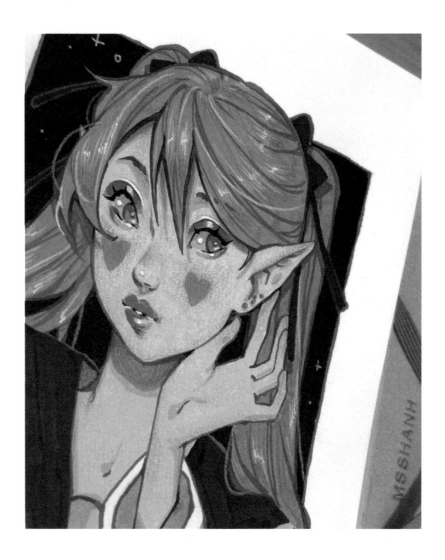

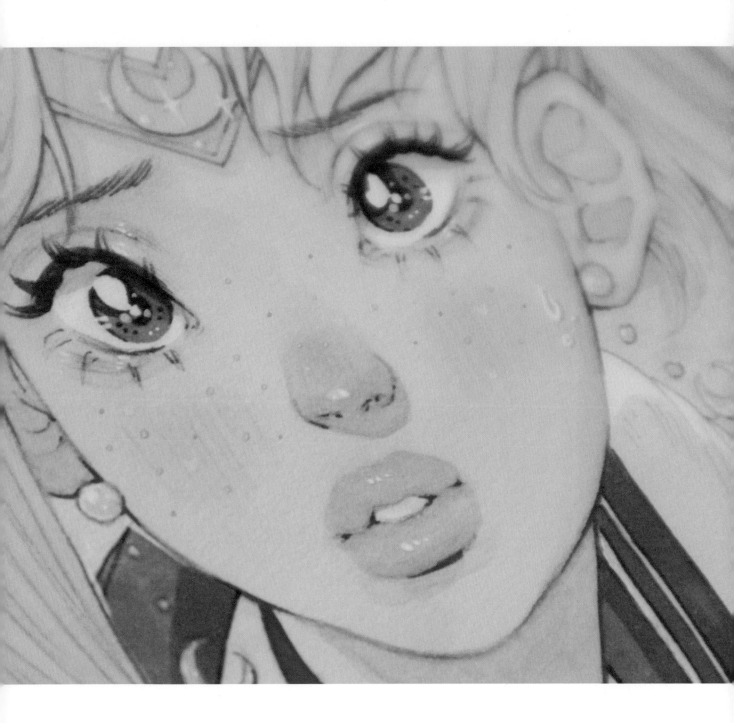

When painting this illustration, I just needed an extra bit of color, and paint markers ended up being my best friends. They're such an easy way to add some extra sparkle to your drawings!

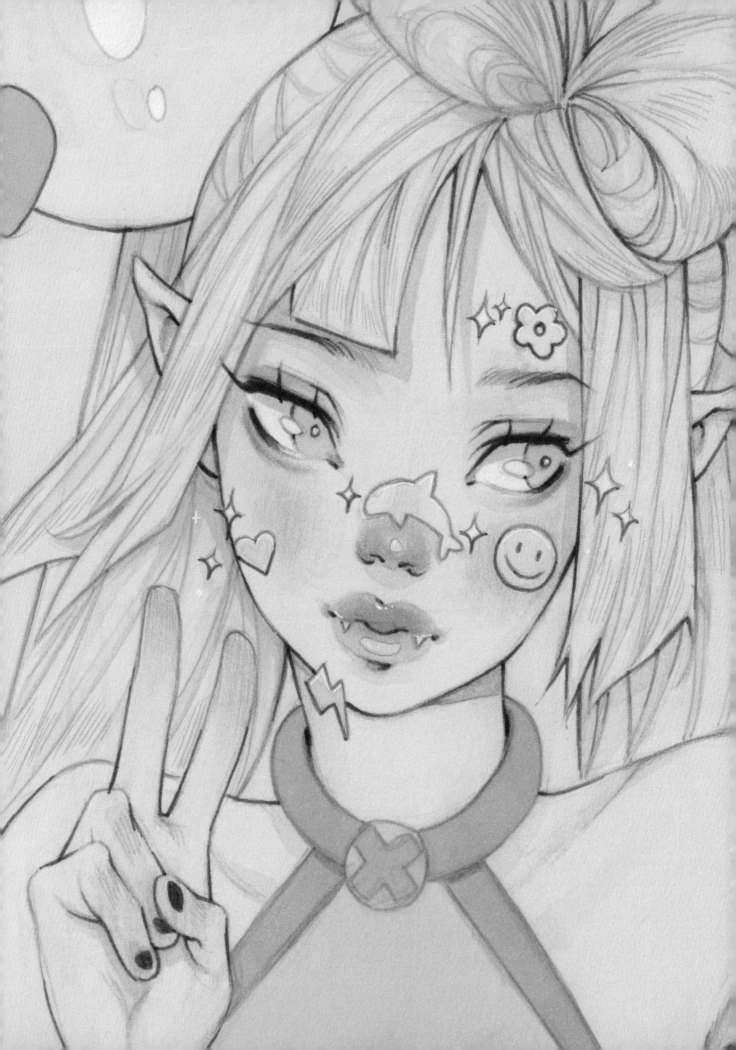

Mastering the Spectrum

Exploring Color Theory

COLORS ARE AN ESSENTIAL PART OF MY ILLUSTRATIONS. They can make or break a piece. I dedicate a lot of time to choosing the perfect color for my illustrations, which is why I've dedicated an entire chapter to color.

Color Theory

The foundation of color is color theory, which teaches the qualities of different colors and how to use them to our advantage. It is important to know the basis of color to make better choices for your illustrations. However, the study of color can go very deep, and there's no need to be an expert to get great results.

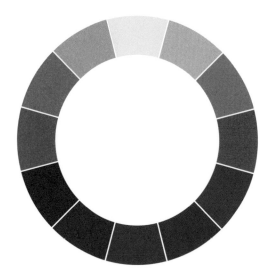

COLOR WHEEL

You might be familiar with the color wheel. It represents the primary and secondary colors divided by their warmth.

Using this wheel, we can create combinations of colors that work together in different ways. We can choose to use colors that are next to each other in the wheel (like green and yellow, for example), creating harmonic gradients. We can also use complementary colors, which are opposite to each other on the wheel. I use this trick whenever I want to add an element that stands out. For example, in a piece that is mostly green, I would add an element of purple if I want it to add contrast and make the element really pop.

The reason it's key for us alcohol marker lovers to understand color is that it's very difficult to mix alcohol markers to create new colors as you would with other mediums, like watercolors. However, one of the benefits of alcohol markers is their transparency. They are made of ink, with a base of transparent alcohol, and they are also permanent once they've been laid on the paper. Knowing all this, we can create new colors just by layering them.

To understand color a bit better, analyze the color palette used in illustrations that you like. Consider why certain colors are used in different areas and in various ways, keeping the color wheel in mind. Colors can be used in so many creative ways, and there's no right or wrong—only what works for you and your style.

I wanted this character to be identified by the color purple, so I incorporated various shades of it. However, to keep it interesting and balanced, I added gold details throughout. The gold is not overpowering and works harmoniously with the purple while still bringing some contrast.

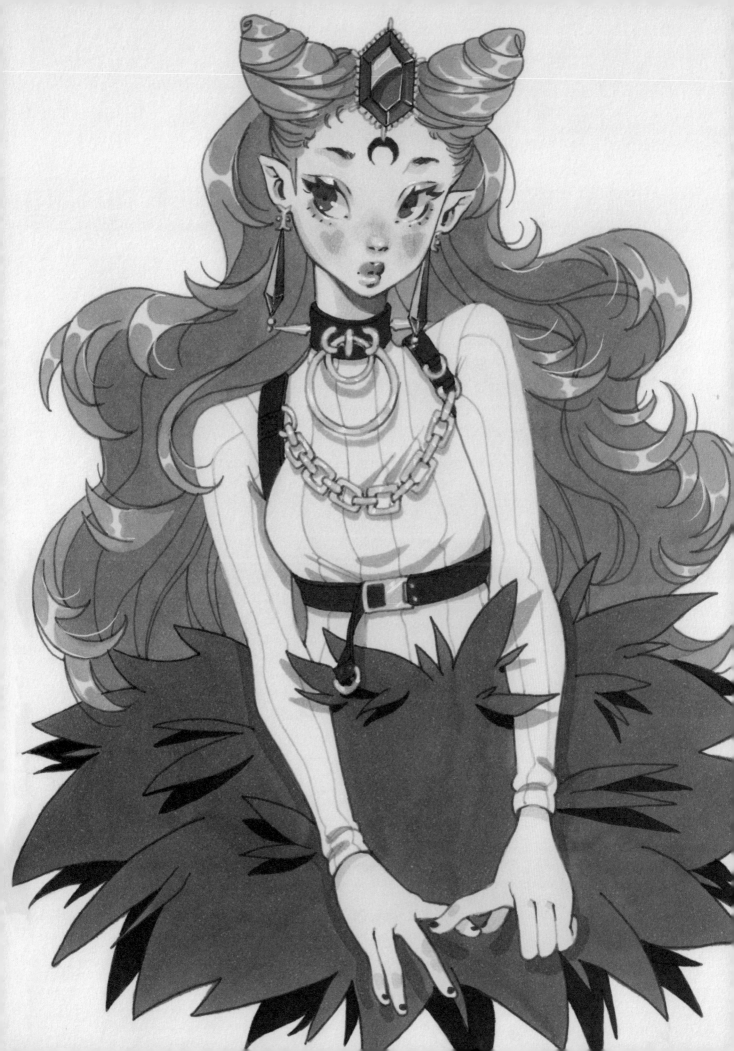

Determine the Color Palette

A big part of getting better at art is to train your eyes to see shape and color. This skill is very important, as it will help you understand the process of how some of your favorite artists use shape and color to create their illustrations. Honing this skill will also help you view colors in a different way, which will make it easier to implement them in your own art and understand why you're drawn to different color palettes and moods.

For this exercise, I would like you to find the color palettes of each illustration and fill in the corresponding bubbles with your alcohol markers or colored pencils. Try to focus on the most prominent colors, but keep an eye out for any highlight, shadow, or contrasting color that seems important to the composition.

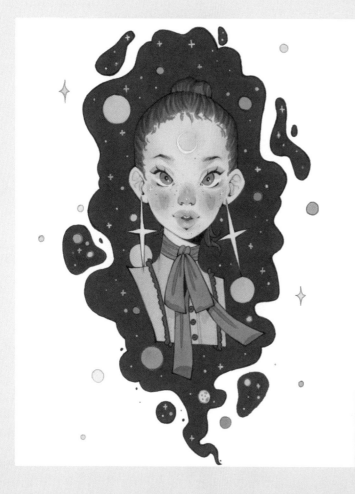

FIND THE COLOR PALETTE:

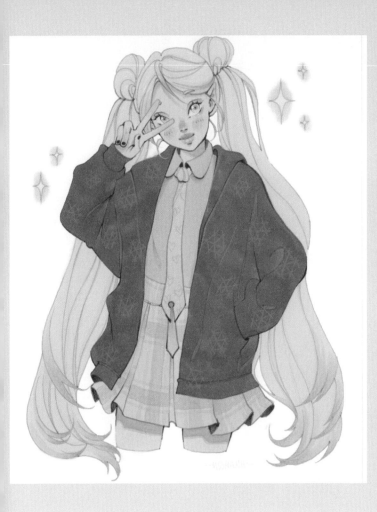

FIND THE COLOR PALETTE:

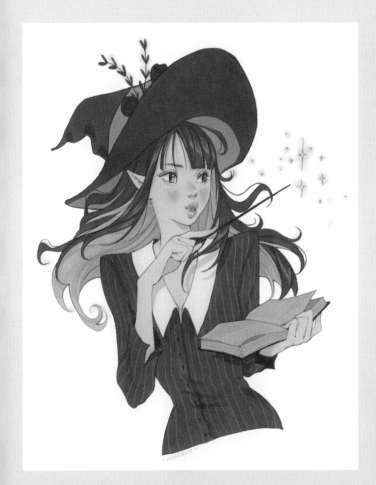

FIND THE COLOR PALETTE:

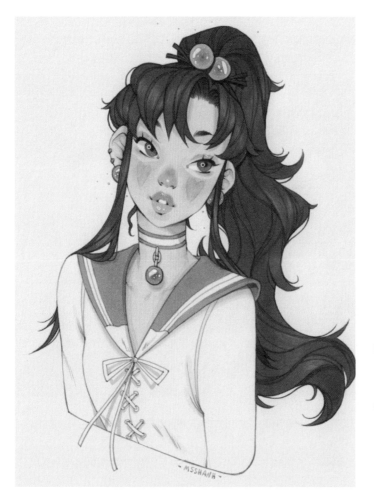

Example of a monochromatic color palette:

How I Choose Color

Color is as much a part of your style as shape and line quality. Think of an artist you like—can you spot any patterns in the way they utilize color?

A helpful exercise for analyzing your own work is to review your illustrations and try to determine your color style, finding the pattern—or patterns. You can also pull together a selection of images that inspire you and consider what it is about the colors of these images that attracts you. Maybe you love the aesthetic of or feel inspired by warm, earthy tones. Maybe it is highly saturated colors, or pastel colors, that move you. Or maybe you prefer monochromatic pieces, or even highly contrasted colors.

Once you have determined what you gravitate to in terms of color, it will be easier to understand your own art.

Even though I used primary colors for the illustration on the right, I aimed to make the colors feel cohesive by using one main color for the line art. In this case, I used a blend of light and dark brown fineliners.

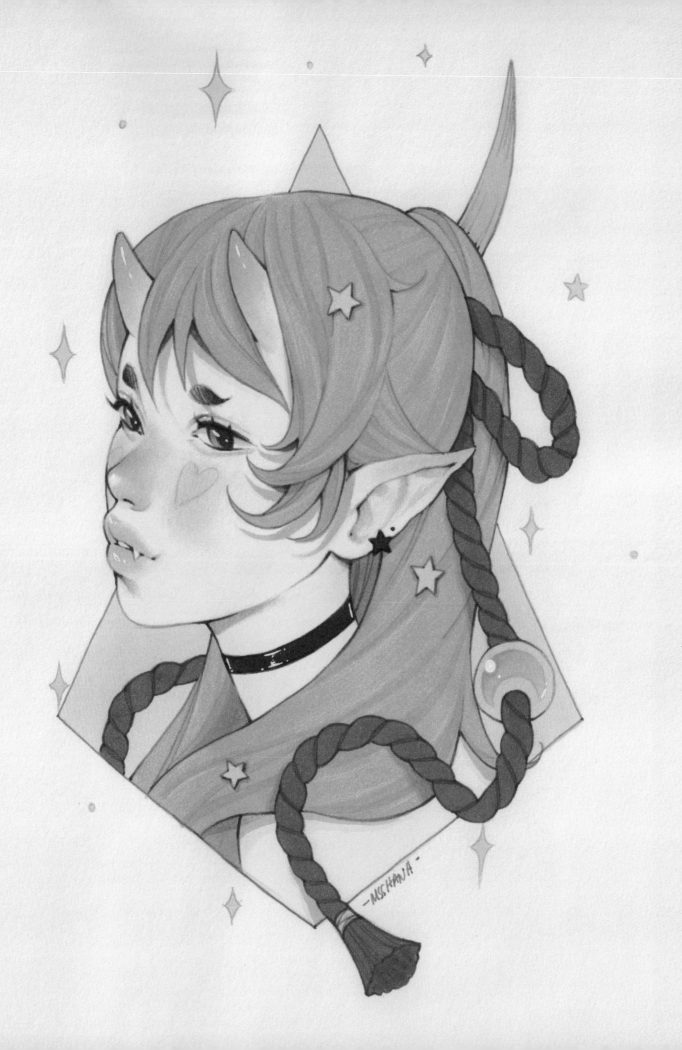

As part of my artistic process, before putting pen to paper, I like to put together a mood board of the colors I would like to use for my illustration. I try to always have this mood board next to me when I create an illustration, even during the sketching process. Color impacts the mood of each piece, and I want my color preferences to be present in my mind—even during the beginning stages of creating an illustration.

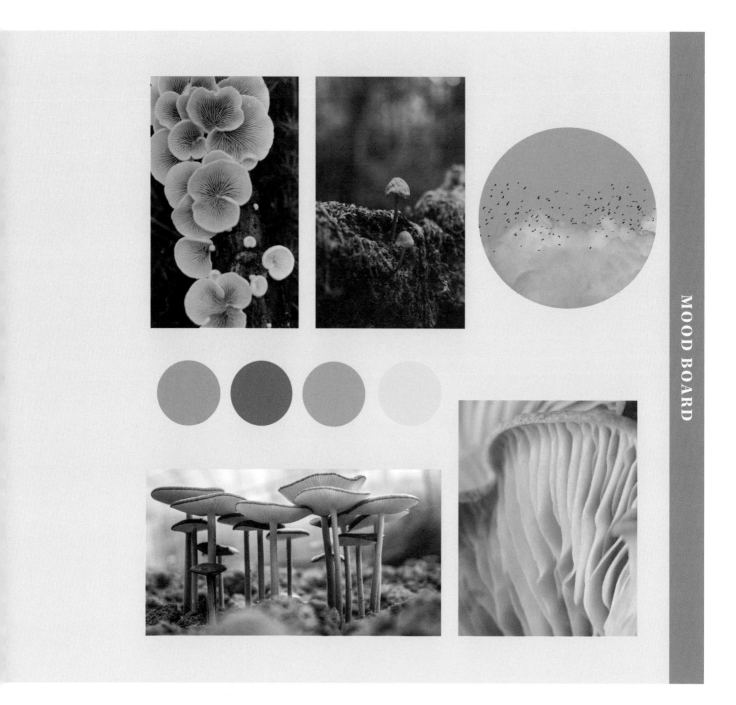

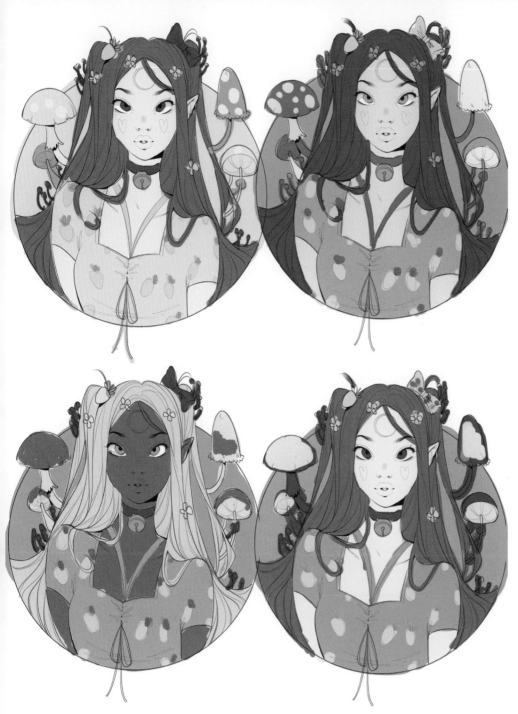

Thumbnailing for Color

Sometimes I have a few different ideas about how to use the colors I choose for my illustrations. I explore these ideas by creating small color thumbnails. I often compose these digitally, but the process can also be done traditionally by drawing small low-fidelity thumbnails of your piece. If you prefer to do this traditionally, I recommend scanning the final base sketch of your piece, and then reprinting it multiple times on the same type—or a similar type—of paper.

This is a great way to experiment with multiple color palettes to find the best way to represent your artistic vision.

The Importance of Swatching

A vital part of the creative process is to swatch each of your colors on all of the different papers you use, always keeping the swatches on hand. This will make your art life so much easier and help you immensely during the painting and color-selection processes. I recommend never skipping this step, even if sometimes it feels pointless.

Not only will every marker look and feel distinct on different papers, but markers will also look different once they have fully dried. So, it is important to know the final, dried result before you put pen to paper for your art project. Swatching on various types of paper is also a great way for you to have a better understanding of your options and your color collection.

Whenever I get a new marker collection, I first swatch a layer of every color in a numbered order, writing the number next to the individual swatch to make sure I don't mix up colors. Once the first layer is fully dried, I add a second layer. This step is important because some colors don't change much with a second layer, while others become much darker with one additional layer. This is the way I swatch my colors and how I recommend you do it too, so that you can see everything you need at a glance.

Here is some information to gather from your swatches:

Final color: An alcohol marker's shade can appear very differently depending on the type of paper used. The ink from these markers can also appear different once dry.

Layering: By adding multiple layers of ink to your swatch, you will be able to see how a marker's color and intensity changes is once you add more layers.

Spread: Depending on both the type of paper and the particular marker, certain inks will spread more on different types of paper, while others will spread less. It is important to know how much your marker will spread so you can be precise and careful in smaller areas.

Color collection awareness: It's helpful to be able to see your full collection at a glance. Sometimes, seeing all of your colors can even help when you are struggling with creative block.

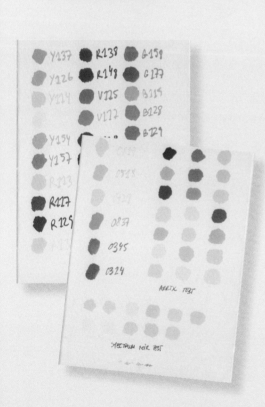

Just as you should swatch your alcohol markers, I recommend that you create swatches for your fineliners and colored pencils, as well. While these materials don't have as much variation as alcohol markers do, it can still be very helpful to have a visual collection of your colored pencils and fineliners so you can know the options you have on hand!

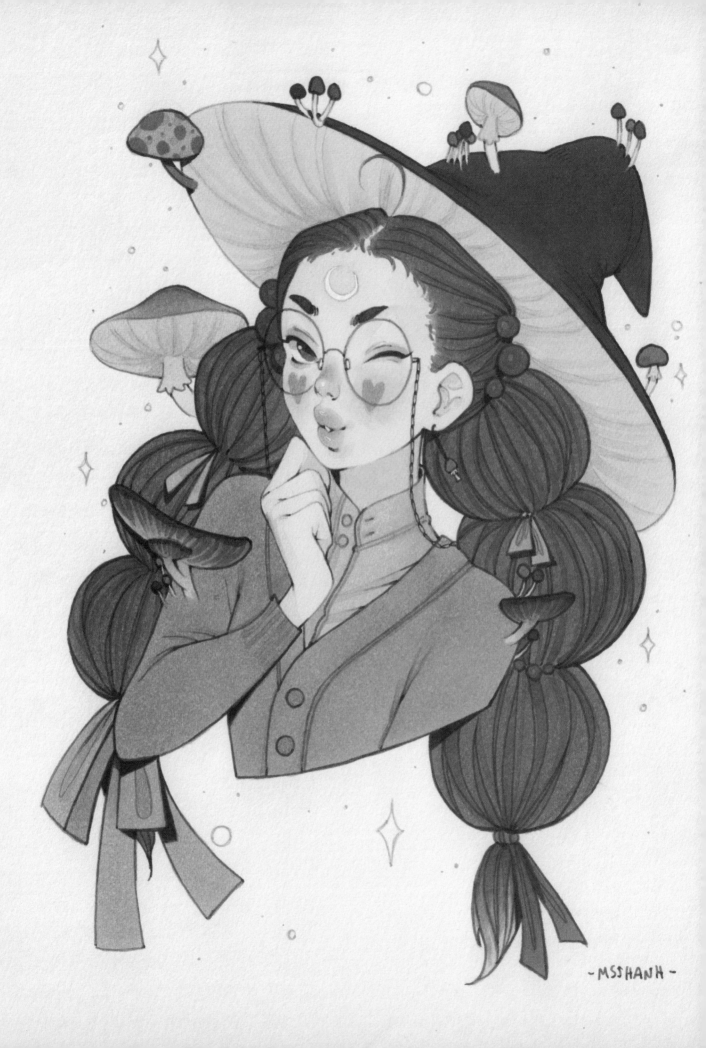

The Art of Blending

Techniques for Seamless Color Transitions

WHEN IT COMES TO ALCOHOL MARKERS, one of the most difficult aspects to master is blending colors, a process that can become very frustrating—and sometimes even discouraging—for those just starting out. Although practice gets us closer to perfection, in this chapter, I would like to discuss some things that make blending easier, as well as what to avoid so you can prevent patchiness in your work.

How to Blend

While blending can be one of trickiest aspects of using alcohol markers, I also find it to be one of the most exciting. You can take advantage of the transparency and buildability of the markers to make entirely new shades. You can also get creative and blend by using just one color.

When using alcohol markers, keep in mind that not every color can blend perfectly with another. To make sure you get the best results, choose colors that are similar in brightness. A very dark and a very light color won't likely blend well together, and the end result can look patchy and muddled.

Let's dive in to the main methods you can use to blend alcohol markers and the best use cases for each.

Priming Method

When using the priming method, the first step is to create a base with the first color (usually the lightest one). Then, without waiting for the first layer to fully dry, add the darker color on top, using a flicking motion with your wrist. This motion is very important for applying the second color correctly, so I recommend practicing as much as you need.

As I add the second color, I alternate between applying more pressure and less pressure, moving through the motion very quickly. If the blending is not smooth enough, you can go back and add some of the lighter color. Because of its transparency, the lighter color will not interfere with the darker one you've already laid.

With this method, you can create a gradient of more than two colors, too, although I recommend that you use this method when blending shades from the same color family.

Flicking Method

The flicking method is similar to the priming method, but this method is better when you want to blend two colors of different hues, as it doesn't involve creating a base.

Using the same flicking motion, you can combine two colors similar in brightness. When determining the colors, there can be a difference in tone, but it shouldn't be a big jump.

As always, to make sure you achieve the best gradient, don't let the markers fully dry on the paper; mixing the colors will be much easier when they're still slightly wet. You can go back to the first color, then back and

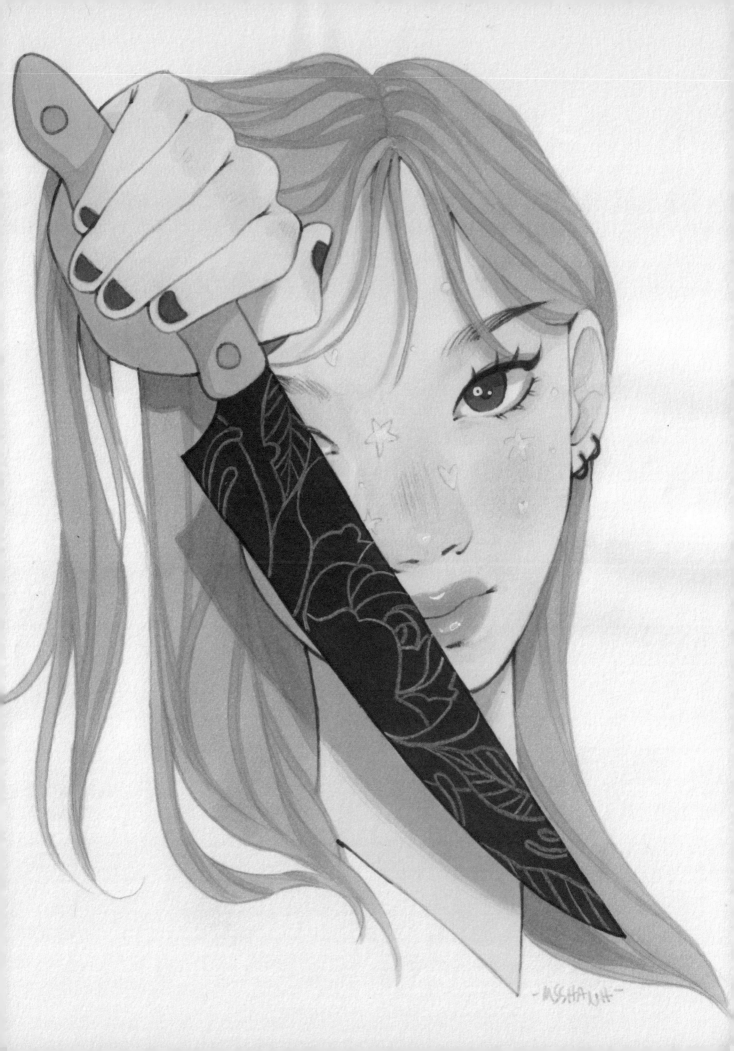

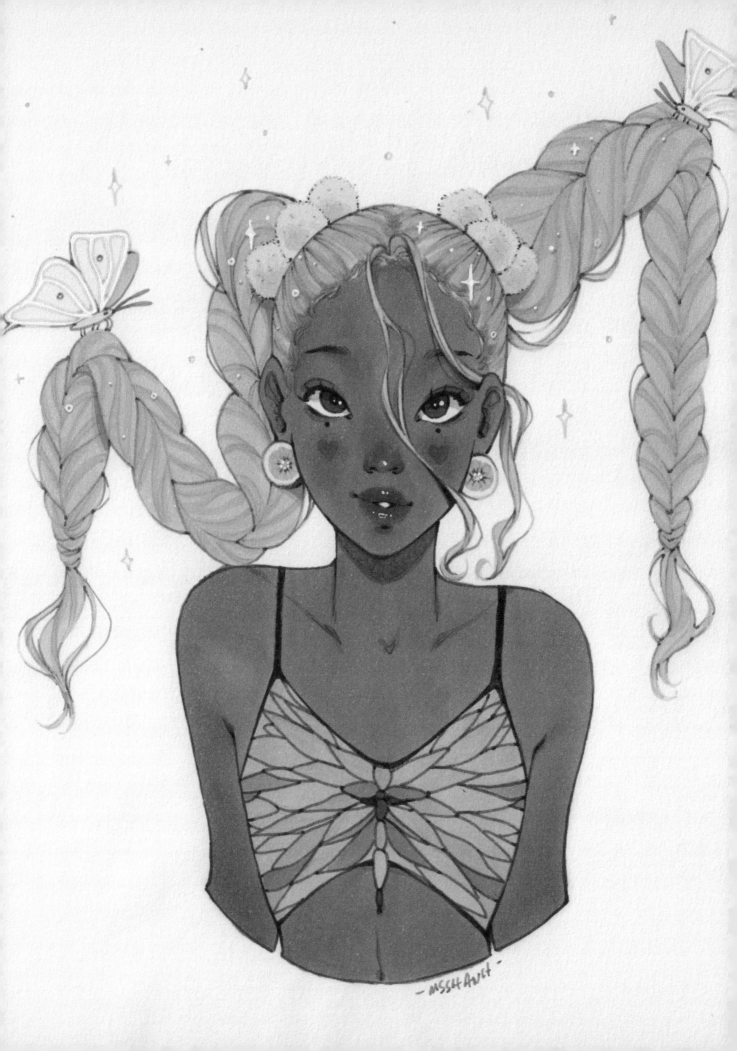

forth between the colors as many times as you need, though bear in mind that the colors will darken as you add more layers.

Nib to Nib

This is a very particular method that I recommend only for smaller areas where you think that using any of the other methods mentioned won't work well.

Take the darker, or more saturated, marker and brush its nib onto the nib of the lighter marker, leaving it there for a few seconds. When you start to see the color changing, take the lighter marker to the paper. For this method, note that the inks will mix, so although you can combine two different values, the colors can become muddy if you aren't careful, so I would mostly use this approach with markers of a similar value.

This method is complex. I don't often use it and I'd rarely recommend it, as it can be unpredictable and it can mess with your markers by temporarily staining your lighter color. However, it is helpful to know how and *where* to use it, as it can be very useful for small, detailed areas, like eyes.

Colorless Blender Marker

Colorless blender markers are essentially alcohol markers, but their ink doesn't have any pigment. These colorless markers are primarily useful when needing to blend an alcohol marker color with the color of your paper—white, in this case. It works best when used with lighter shades of alcohol marker, as it's harder to create a similar gradient with darker colors. A colorless blender can be used with any of the methods mentioned before; just use it as if it were any other colored marker, but know that it will dry out fully transparent.

The colorless blender approach is a mystery for some and I don't often use it in my illustrations, but it can be helpful when you want to create certain effects or textures. If this method interests you, I highly recommend experimenting with these markers so you can become more familiar with how they work.

Blending with Just One Color

One of the qualities I love most about alcohol markers is their ability to build up color. You can create a gradient using only four one color by employing the priming method. To do this correctly, you must make sure to let the base dry completely, which should only take a couple of minutes. Then, create a second layer using the flicking motion. Once again, let it dry, and carry on a third time if needed!

This is my favorite method, and I use it all the time, especially for skin. When filling in skin color, it looks best if you can get smooth transitions, and that's easier to accomplish when you use one marker to create multiple layers of smooth, rich color.

PRO TIP

If you do want to create a gradient that blends a very light color with a very dark color, you'll need to use intermediate colors to help achieve a less patchy gradient. I'd recommend using around 4 intermediate colors—two on the lighter end of the desired color palette, and two on the darker end of the color palette. This can be hard to accomplish if you don't have a large selection of colors to choose from. However, it can still be good to practice this method so you can better understand how these contrasting shades interact with one another!

Priming Method: For this particular example, I chose a light yellow marker and used its chisel nib to create a solid base. Moving quickly, I then used the brush nib of a greenish-yellow marker and, starting from the left, added a top layer. Adding this second color while the base was still wet allowed me to create this nice gradient.

Flicking Method: To create this purple-to-blue gradient, I started with the brush nib of a blue marker and added color from the right side of the practice box into the middle, using a rapid flicking motion to spread the ink quickly. Again, without letting this first layer completely dry, I used the brush nib of a purple marker to bring the second color in from the left side to the middle. From there, I alternated between both markers to add several more layers and create a more seamless gradient.

Nib to Nib: Starting with a bright pink marker, I primed its chisel nib with the brush nib of a dark purple marker. The chisel nib takes in more color, so it's most effective to use the base color's chisel nib and add color with the darker color's brush nib. Then, I created a smooth line moving in one direction, allowing the ink from the darker color to gradually bleed and disappear into the lighter color's ink.

Colorless Blender Marker: To create a gradient using the color of the paper as a base, I again utilized the priming method and laid a starting layer of ink with the colorless blender marker. Before that base dried completely, I added a second layer with a medium blue shade, flicking the pigmented color into the transparent ink.

Blending with Just One Color: For this example I used the chisel nib of a medium-green marker and created a flat base of the color. After letting it dry for at least ten minutes, I then used the same marker's brush nib to create another layer, moving from left to right, ultimately producing a subtle gradient between values. You can repeat this process as many times as you want to darken the values and create a more contrasted gradient.

Now you try! Flip to the practice paper in the back of the book or an empty page in your sketchbook to test out these methods. You can use any shades you want, but keep in mind to follow my recommendations for choosing markers from the same color family or that have similar values.

NIB TO NIB

PRIMING METHOD

FLICKING METHOD

COLORLESS BLENDER MARKER

BLENDING WITH JUST ONE COLOR

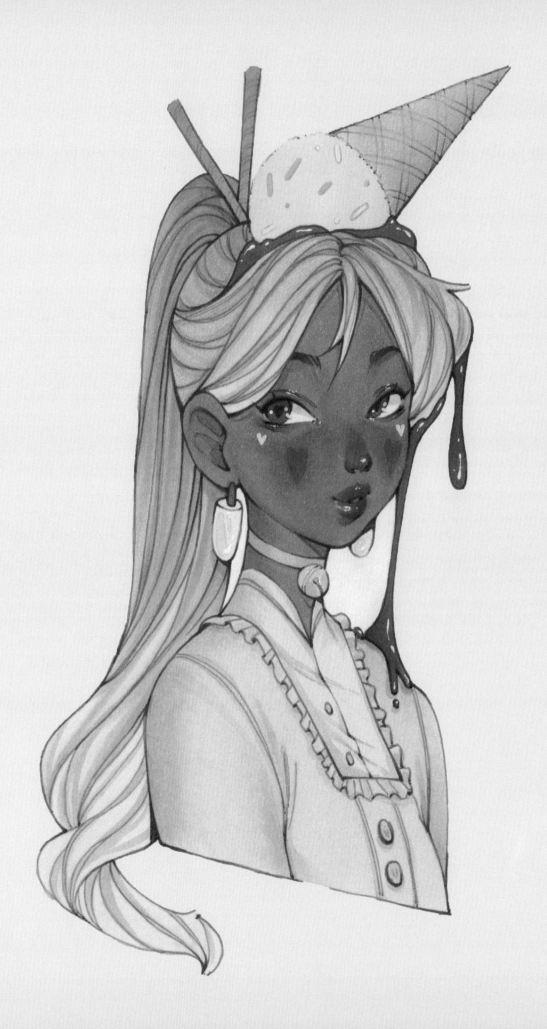

Developing Your Personal Art Style

Finding Your Unique Creative Voice

THE TOPIC OF ARTISTIC STYLE is one that really interested me when I was a young artist. I think many new artists can relate: when you are just starting out it can be difficult to figure out your style, and sometimes it is easy to feel lost and frustrated when our art looks too generic or too much like the artists we reference.

I definitely felt like that, but with experience—and after getting to talk with and coming to know some artists that I truly admire—I got to understand better what artistic style means and why it shouldn't be such an obsession when starting out.

In this chapter, I'll share with you some of those lessons I learned, as well as some tips, tricks, and exercises that can help you unlock your personal style.

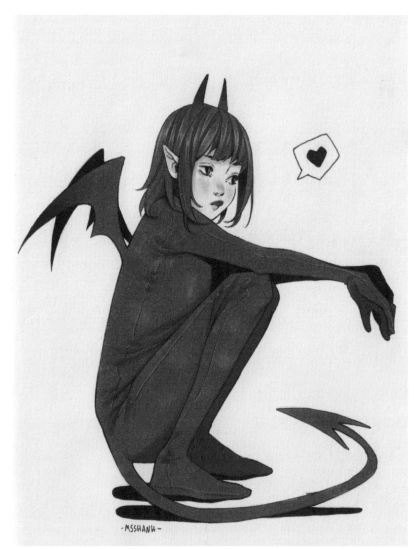

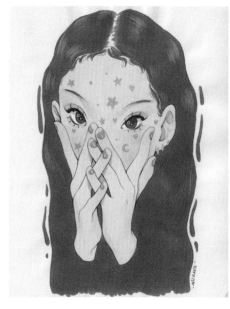

There are certain compositions and colors that I love to use, like the overuse of very bright reds, close-up portraits, and decorative elements like stickers and stars. I sometimes feel bad for using these elements as much as I do, but when I am in a creative block, I let myself be self-indulgent and just enjoy the things that I love. There's no shame in only drawing the things you love—no one says you have to be versatile!

Let's Talk Style

The first question we need to answer is: what defines an art style?

When it comes to illustrating, artistic style is the combination of different attributes an artist brings to the creative process. I consider these attributes to be the following: line quality, subject matter, color choices, form and shape, and composition.

Line Quality

How you treat your lines when illustrating is one of the main defining factors of your style, and it is actually one of the first stylistic choices we make when we're just starting out in illustration—sometimes without even noticing.

If you think about a few of your favorite artists, you may quickly realize that the way they treat lines and line art differs greatly from one to the other. It is often an illuminating exercise to go through their portfolios and try to focus only on the way they choose to line their work: it will help you understand the importance of lines.

Some artists consciously decide not to care for their line work, making it messy or inconsistent; but even this is a stylistic choice that defines their personal art style.

Subject Matter

What we choose to draw or create also contributes to our personal art style. We all have things we love to draw more than others, which becomes as much a part of our style as anything else.

Some artists like to focus on environments and robots, while others may draw feminine characters, and others prefer to draw animals and plants.

Sometimes, we might feel as though we are limiting ourselves by always drawing the same subject matter. Although it's true that trying new things will help us develop our styles further and prevent our art from becoming stagnant, you shouldn't feel pressure to experiment with subjects you don't want to. All of those decisions, whether conscious or not, are part of your style.

WORKING THROUGH CREATIVE BLOCK

Feeling stuck in a creative block can be frustrating as an artist, and it can sometimes feel impossible to create anything that you like. Having personally been in this situation many times, I've found some tricks that help me get back my creative juices.

• Redraw an old piece: This has offered me a boost of confidence anytime I've felt like I was stuck in my artistic journey. Find an old drawing of yours and recreate it using your current skills. You might be surprised by how much you have improved, as well as how much easier it is to spot where the mistakes are.

• Try a new medium: Sometimes, using the same medium again and again can drive us into a creative rut. When this happens, I like to test out new or rarely-used mediums. This helps me reset my brain, and I always find different ways to use and incorporate these new materials in my illustration process.

• Indulge in the things you like: Pushing yourself to try new things can definitely help with creative block, but sometimes, going back to drawing the things you truly enjoy is the best way to feel creative again.

• Join an art challenge: We're so lucky to live in an era where we can find other artists online and create a great community. If you're ever in need of a creative boost, there are monthly challenges you can join— like Sketchtember, Inktober, and 36 Days of Type, to name a few—that will help challenge your art in many different ways.

Color Choices

We touched on color in Chapter 2, and we are revisiting the subject here, since color is a vital part of a personal art style.

It is not only the colors we choose but also the way we treat them that characterizes artistic style. Once again, some artists decide not to use color at all, which is also a choice of style that impacts their illustrations.

Color might be a part of your style that you are still figuring out. It took me a while to fully understand how I wanted to treat colors myself and what part color would play in my illustrations. That is why I think color needs extra care and mindfulness.

Form and Shape

This subject can be a little vague and difficult to explain, but it is one of the main elements of art styles.

This mode of understanding art style considers the way an artist treats their shapes and forms, applying to everything they draw. One way to discern this would be to focus on a particular element of an illustration—for example, the way an artist draws hair for their characters. Maybe they draw it very flowy, soft, and weightless, while other artists draw it blocky and stationary.

If you examine the work of an artist who doesn't use lines in their final work, you could still recognize their style on a sketch they've done, even when a sketch is purely lines, and they don't use lines in their finalized work. This is because the shapes they use and the way they recurrently draw specific elements are very recognizable.

When in doubt, just add decorative elements to your illustration!

MY PERSONAL ART INSPIRATION

My inspirations and references have been many and varied, some of them already mentioned previously. If you like my style, you might enjoy browsing the works from these artists who have inspired me. I think they will inspire you, too.

- Barbara Canepa
- Alessandro Barbucci
- Satoshi Kon
- Lois Van Baarle
- Chris Hong
- Sibylline Meynet
- Manuel Pérez Clemente, better known as Sanjulián
- Frank Frazetta
- Leslie Hung
- Luis Yang

These names constitute only a very small list of artists who have inspired me and who keep inspiring me every day.

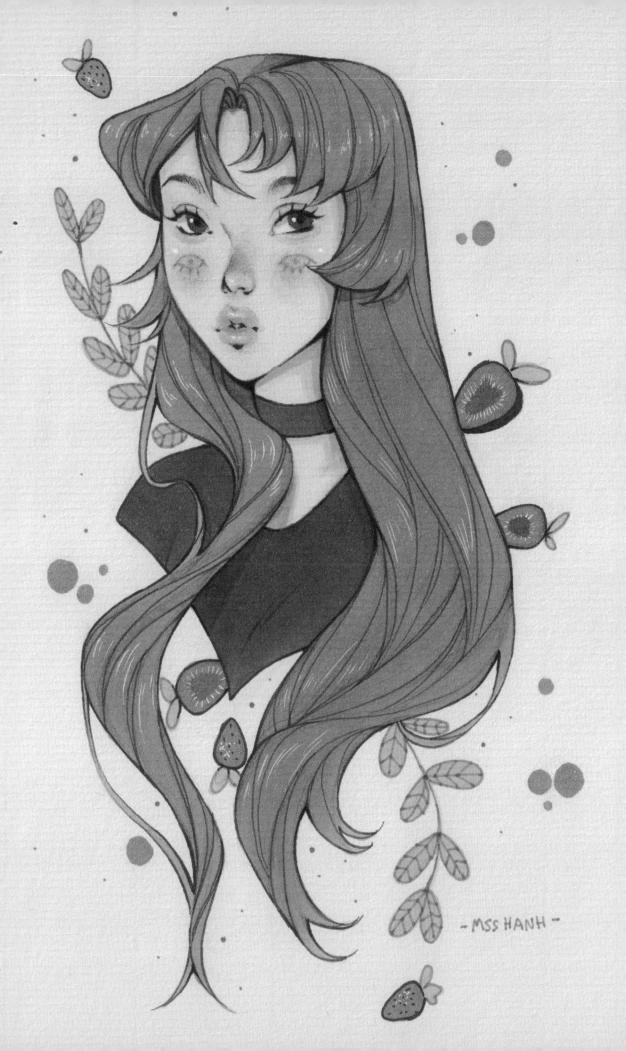
- MSS HANH -

Composition

This is an aspect that can sometimes be overlooked, but it often has great bearing on what makes a style recognizable.

Composition refers to where and how an artist positions their subject matter on the canvas. For example, one artist may love portraits, which would become the main composition they use. I remember when I was starting out, I was frustrated at the fact that most of my compositions consisted of a character floating on the page. Naturally, that is very much part of my style, and I could have chosen to keep it that way. But I recognized that this composition was a part of my style that I wasn't happy with, so I challenged myself to change it.

A DEEPER DIVE

Now that you know the main elements that make up an artist's style, let's work on finding yours! Take a moment to analyze your previous sketches or finished artwork, determining what you like (or dislike) within each piece.

Line Quality: Look to see if there's a common style of lines in the pieces that you most love. Is there a certain style of line work that draws you in? Do you most like loose, messy lines, or clean, structured ones?

Subject Matter: Is there a subject matter you seem to be most drawn to? If you don't see an obvious commonality, is there a certain mood or vibe that sticks out in each piece?

Color Choices: Color can be one of the trickiest style elements to nail down, and like with the other elements, color preference can change many times throughout your artistic journey. During this exercise, just see if there is a certain color palette or style that speaks to you right now. Are you currently drawn to monochromatic palettes with warm hues, or do you like more dramatic pieces with contrasting colors? Do more feminine pieces with light pinks and blues attract you, or are you more interested in rich, earthy tones?

Form and Shape: Now take a moment to review the shapes on the artwork. Do you prefer more rigid, blocky shapes, or soft, wavy ones?

Composition: Take a look at your favorite illustrations or sketches. Is there a type of composition you prefer? Is there a type of composition you don't like?

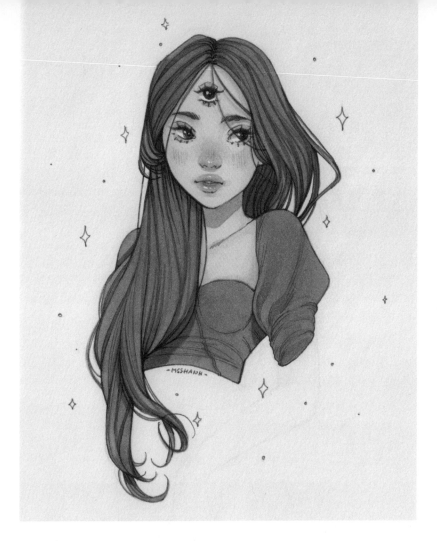

Find Your Style

It's important to recognize these various elements of style so that you can analyze your own artistic style and understand it better. This knowledge empowers you to change your style or use it to your advantage in a more mindful way. Now that you're familiar with these main elements, you might be wondering how you can find your own style—your unique way of treating art so it is both recognizable and represents you.

You likely already have an art style, or at least the makings of one. If you refer to the previous sections while considering your own art style, you might find patterns in each of the categories we talked about. Or it might be that those around you can recognize a specific style to your art, even if you, yourself, can't yet see it. Determining and refining my own art style took me a long time to figure out, and it proved a major frustration

for me. This is why I'm determined to help other artists become more cognizant of what style means and the different elements that make it up.

We might find ourselves thinking we don't have an art style of our own because the elements that constitute it are hidden or not noticeable yet. But with practice and time, those elements will develop further and become more noticeable.

An important element that contributes to our style is our personal visual library from which we pick and choose elements to adapt for our own style. Also, personal art styles are often dynamic and grow or change alongside us; they are reflections of us as individuals. As we keep experiencing life and change as people, our art also changes.

The Importance of a Visual Library

To put it simply, a visual library is made up of everything that you've ever seen and experienced in your life. A visual library is unique to each individual, as we all have different life experiences. It is the place in your head where all of the resources you use to create your art live.

This library is not only made of things you like, but also of things you don't like and actively or subconsciously choose not to use in your art. Because this impacts your art so much, I think it is very important to nourish and grow your visual library. Something as simple as watching a movie or flipping through a fashion magazine, if done mindfully, will directly benefit your art.

At the end of the day, beginning to make art can be thought of as simply as putting together a whole bunch of references that are unique to us. We take the common everyday things that we see and transform it into art. A varied and vast visual library will give you the tools you need for creating, and it goes beyond just inspiration.

Create Your Own Visual Library

If you want to expand your visual library and give yourself more tools to develop your art style, here are some suggestions for how to explore deeper, gleaned from my own day-to-day life.

Art Books

Art books are a great source of inspiration for me, and they often help me when I feel a creative block coming my way. Though I have built up my collection after many years, art books can be expensive, but libraries and used bookshops are a good alternative. In the most helpful art books, artists will discuss the things that inspire them, and what their thought process was to achieve a certain look or design.

Films and quality television can also provide ample inspiration. You may also read interviews from the filmmakers you respect the most, which can offer insight into their creative processes. Although film and illustration are vastly different mediums, you can often find through lines of imagination in both.

Being able to see what is behind the art that inspires us gives us a different point of view and an insight into the creation of art.

Here are ideas for books I find very inspiring that might not be something you have tried before: art books about films you're visually drawn to, photography books, graphic design and typography books, interior design books and magazines, and storyboards from your favorite films, shows, and/or comics.

Day-to-Day Life

Active awareness and presence in life is something I try to practice every day. Whenever you travel around your own city, visit a friend, or even go on vacation somewhere new, try to find presence of mind and pay close attention to your surroundings, seeing what new elements you can notice.

When we are aware of our surroundings, the inspiration we can find in the world is boundless and can contribute to our visual library—whether it be a stunning chandelier shop you never realized was there before, a particularly beautiful sunset, or a moment while waiting for your train. There are so many things to experience, and sometimes it isn't even visual elements but feelings that we open up to.

Try to capture those moments.

Art Galleries, Museums, and Exhibitions

London, where I live, is home to some incredible museums, and even back home in my small town, I visited small, independent art galleries that occasionally featured different artists. I love keeping up with both small galleries and big museums as a way to discover new art that I wouldn't normally gravitate toward. Try to find a gallery or museum near you and visit it regularly, making a point to experience art from artists you've never seen before.

Other Artists and Friends

Talking about art with other artists can be very powerful, as it can demystify the beliefs and thoughts of other artists. It can also be conducive to sharing your inspirations and discovering what other people are inspired by.

Sometimes, I find conversations with other people (not just artists) very inspiring, too, like the way they express themselves or the thoughts they have, even if those thoughts aren't art-related.

Listening to friends, family, acquaintances, or even podcasts can be of great help with inspiration, especially in the storytelling department, and what you discover can certainly become part of your visual library.

Social Media and Portfolios

One of the many reasons I'm so grateful to be living in the twenty-first century is how accessible art has become. Social media is a perfect way to find references and inspiration from people you follow, but also for things that are a bit more difficult to find the traditional way.

I use Pinterest as a tool to find scans of Japanese fashion magazines from the nineties and early aughts, many of which I wouldn't be able to find offline. I try to always keep up with my favorite illustrators on Twitter and Instagram, saving those illustrations that inspire me the most as references to revisit whenever I need a bit of extra inspiration.

A Note on Social Media

SOCIAL MEDIA PLAYS AN IMPORTANT, EVEN FOUNDATIONAL, ROLE in our visual library, and it can heavily impact our art even without us realizing. This has happened to me and my art. Before social media, my visual library was made up of things I would actively search for—it felt more unique to me, made up of movies, comics, books, and other media. My current visual library is much further reaching now. Since the rise of social media, many of us fear that we're all being fed the same types of images by various, ever-evolving algorithms that are "contaminating" our visual libraries. I've seen how my art has changed in direct response to more time spent on social media.

I don't think this is necessarily a bad thing, or somehow less noble. I am grateful to have access to so much art via social media platforms; I've gotten to discover smaller artists who otherwise I would never have found. But it's important to be aware of this phenomenon—and the rising ubiquitous presence of social media—so we can be more conscious of how it affects our art, and whether we want it to have that kind of power. It is all about finding a balance.

Spend some time reflecting on your art. Take a break from social media to let your brain breathe. Try to be more conscious of how you spend your time on social media—whether you scroll endlessly or take a more intentional approach. Being mindful and searching for what really matters to you and your art can be liberating.

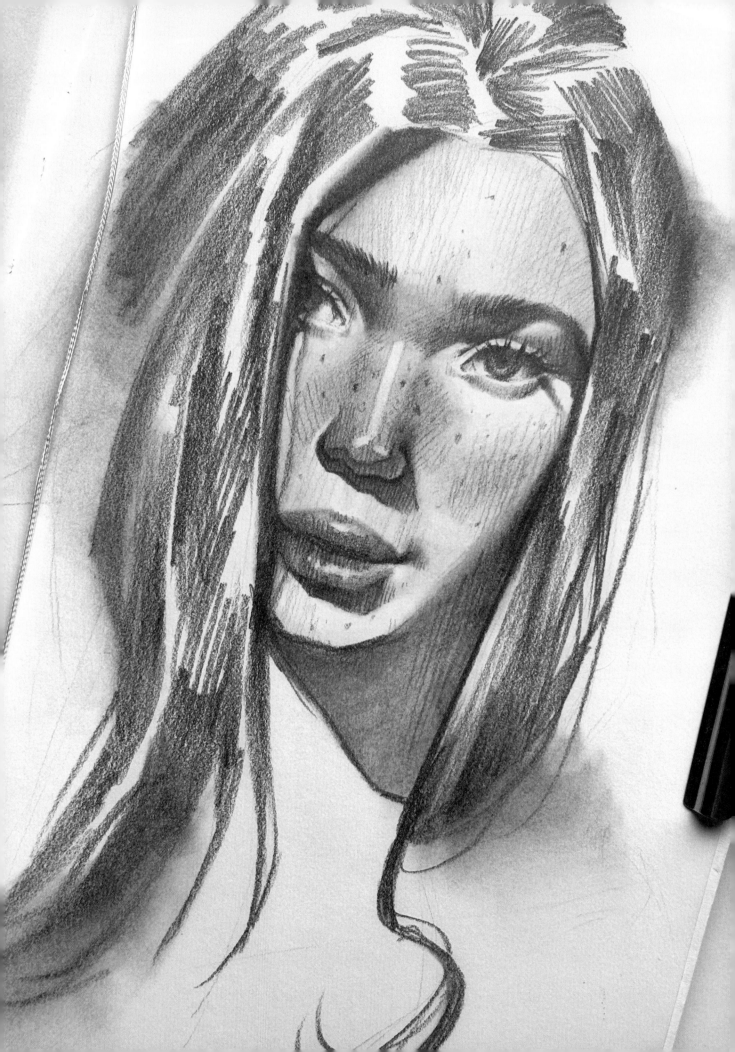

Starting with a Sketch

Crafting the Foundation of Your Character

NOW THAT WE'VE COVERED THE BASICS of illustrating with alcohol markers—from the tools you'll need to get started, tips for choosing color palettes, and tricks for working with alcohol markers—it's time to get drawing! Grab a sketchbook or practice in the spaces provided and follow along as I walk you through how I create the basic shapes and forms for character illustrations.

As you practice sketching these basic shapes, I recommend that you place your grip higher up on the pencil than you normally would when you write. This will allow you to be gentle and place less pressure on the paper. During these beginning sketching stages, less pressure is always better, as this will help you to make changes if you make a mistake or decide you want to go in a different direction.

Heads

WHILE THEY MAY SEEM complicated, you can actually construct heads in a very simple way.

Start by drawing a circle—this will serve as the main shape of your character's head, which we will build off of as we go. Whether you want to draw your character head-on, have their head tilted to the side, or show them in profile view, you will always want to start with a basic circle.

Now you can add the angle and shape of the head. During this step, it can help to draw a line to signify the eyes, nose, and mouth. To make sure that the direction of the head is exactly the one you want, I find drawing lines for the eyes and a directional line down the middle of the face is the easiest way to achieve a good result. However, I use the eye lines just to make sure that both eyes are aligned, but I sometimes choose to draw the eyes just above or just below the line, depending on the look I am going for.

Next, you can begin to add basic lines to signify certain details, like hair shape, clothing, and any accessories that will appear near the head. These areas don't need to be fully flushed out at this point—we will have an opportunity to add in details later.

Whether you use your sketchbook or the practice sections provided, practice drawing these examples, making sure to try out multiple different angles. This is also a good time to practice playing with face shape. While not always the case, face shapes can be good tools for emphasizing a character's persona. For example, this character has a rounder face, which gives off a more innocent, youthful vibe.

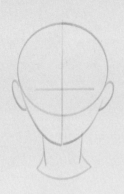 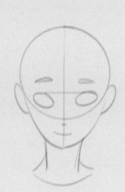 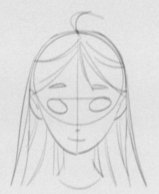 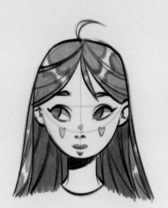

STEP 1 **STEP 2** **STEP 3** **STEP 4**

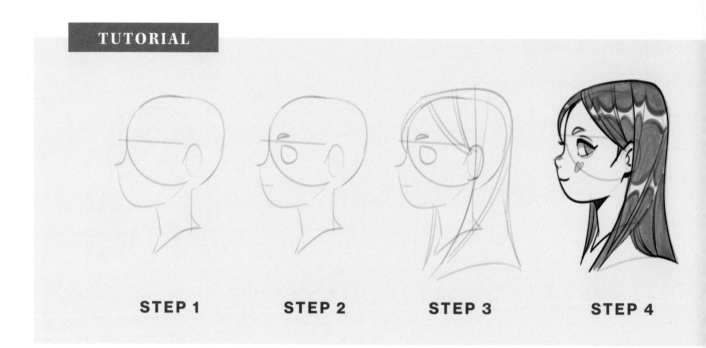

STEP 1 STEP 2 STEP 3 STEP 4

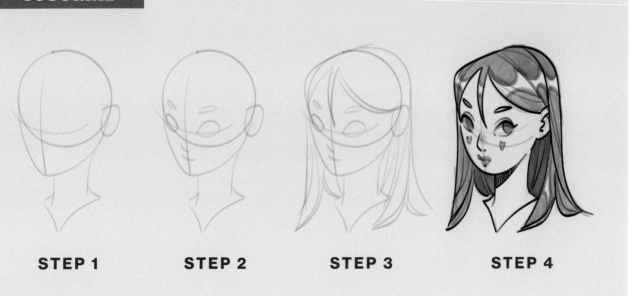

STEP 1 STEP 2 STEP 3 STEP 4

Eyes

BECAUSE I MOSTLY CREATE portraits, eyes are super important in my art, as they represent the soul of a character. However, eyes can be one of the trickiest features for beginners to master.

To make sure that the eyes of a character accurately represent the attitude you want them to have, start by focusing on the base shape of the eyes. I always start by drawing a rounded shape. Just by seeing it, I can tell if it is the correct eye shape for that character.

PRO TIP

Round eye shapes are typically used for younger, cute characters. Round shapes can also signify emotions like happiness, excitement, and wonder. On the other hand, longer, sharper shapes can insinuate a mature, seductive, angry, or suspicious nature.

Following these examples, test out a few different eye shapes in your sketchbook. Notice how, just by making slight adjustments to the shape of the eye, the placement of the iris, or the angle of the eyebrow, you can drastically alter the apparent emotion of your character.

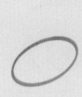
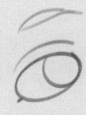
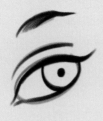
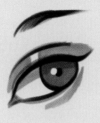
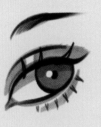

STEP 1 **STEP 2** **STEP 3** **STEP 4** **STEP 5**

ET'S PRACTICE

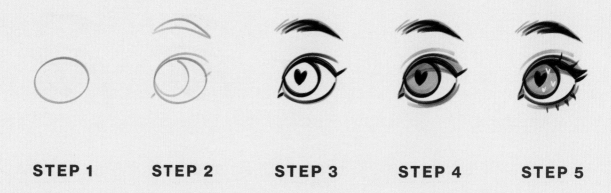

STEP 1 STEP 2 STEP 3 STEP 4 STEP 5

LET'S PRACTICE

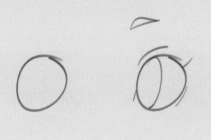 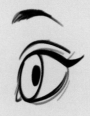 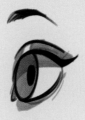 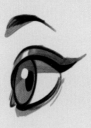

STEP 1 **STEP 2** **STEP 3** **STEP 4** **STEP 5**

ET'S PRACTICE

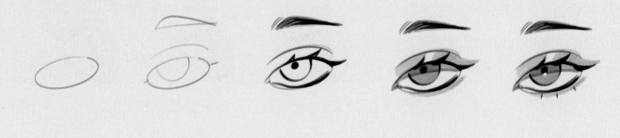

STEP 1 **STEP 2** **STEP 3** **STEP 4** **STEP 5**

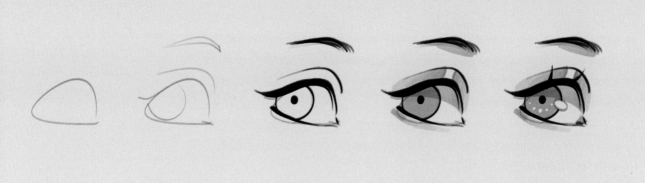

STEP 1 STEP 2 STEP 3 STEP 4 STEP 5

Noses

BECAUSE MY ART IS highly stylized, I prefer to draw very simplified noses. Sometimes, they are reduced to just being a couple of lines. Nevertheless, it's still important to understand some of the different angles and how a nose looks in different directions.

Noses can be difficult to get right, so if you're a beginner, I highly recommend sticking with simple noses for now, so you can become familiar with the proper angles.

Practice drawing these example noses, paying attention to how a few slight line adjustments can change a button nose to an upturned nose.

PRO TIP

If you really want a challenge, grab a mirror or your phone's camera and practice drawing your own nose from different angles. You could also ask for volunteers from your family or friends to help you get practice drawing different types of noses!

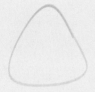

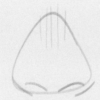

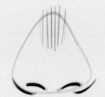

STEP 1 **STEP 2** **STEP 3** **STEP 4**

ET'S PRACTICE

STEP 1 **STEP 2** **STEP 3** **STEP 4**

LET'S PRACTICE

STEP 1

STEP 2

STEP 3

STEP 4

ET'S PRACTICE

STEP 1 **STEP 2** **STEP 3** **STEP 4**

LET'S PRACTICE

Lips

LIPS HAVE TO BE one of my favorite things to draw. Lips are a very expressive part of the face—as much as the eyes are, in my opinion—so pay attention to them when creating your character.

To practice drawing lips, start with the area where the lips meet. Drawing these inner lines first will help you create the mouth's expression.

Then, add the outer lines of the lips to create the mouth shape and size. From here, you can add details, like shadows or lip gloss shine.

PRO TIP

Just like with noses, it can be so helpful to use your own mouth as an example. While you're in front of the mirror, practice making different expressions with your mouth—from pursing your lips, to holding them open in surprise, to smiling wide. You may feel dumb while doing it, but it can be so helpful as you're starting out!

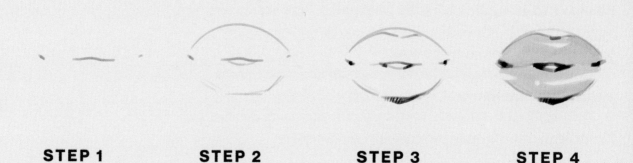

STEP 1 STEP 2 STEP 3 STEP 4

STEP 1 STEP 2 STEP 3 STEP 4

STEP 1 STEP 2 STEP 3 STEP 4

STEP 1 **STEP 2** **STEP 3** **STEP 4**

ET'S PRACTICE

Hair

I REALLY ENJOY CREATING different hairstyles for my characters—hair can be so fun to draw! For the longest time, I struggled with drawing hair that didn't look stiff and lifeless, but I have now come up with a method that works great for me and helps give my character's hair movement and volume.

The key to realistic hair, regardless of how stylized your personal style is, lies in directional lines.

In the first example on page 91, you'll notice how I've created the illusion of bouncy hair by drawing directional lines away and up from the character's face. In contrast, the character on page 92's light and wavy hair was created with lines that move both away and toward her face.

You can make long, straight hair look different just by drawing directional lines with a bit of curve. The character's hair on page 93 looks light and flowy, rather than flat and heavy, because the directional lines are slightly angled rather than drawn straight down.

For textured hair like the character on page 94, the key is to make short brushstrokes, varying the direction of the lines around the head. This method can help emphasize volume and a tighter curl, whereas longer lines imply a looser curl.

Following these examples, test out different types of hair on these practice pages or in your sketchbook. Do you notice how different types of directional lines can create varying styles of hair?

BOUNCY
HAIR

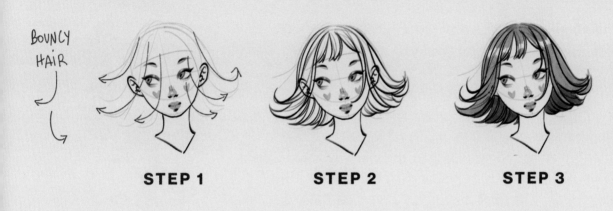

STEP 1 STEP 2 STEP 3

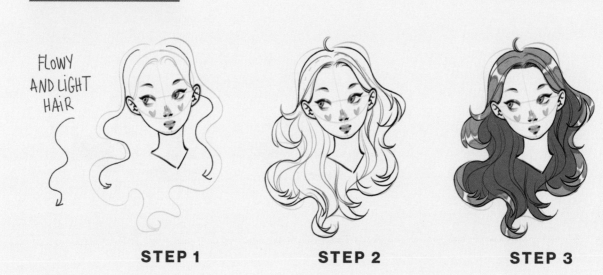

FLOWY
AND LIGHT
HAIR

STEP 1 **STEP 2** **STEP 3**

LET'S PRACTICE

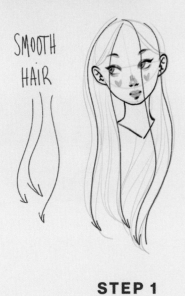

SMOOTH HAIR

STEP 1

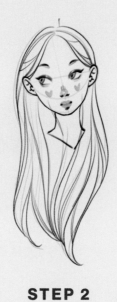

STEP 2

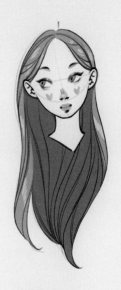

STEP 3

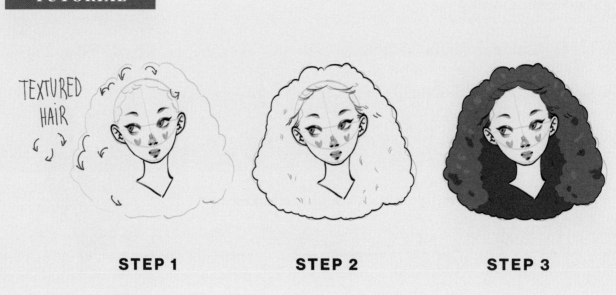

TEXTURED HAIR

STEP 1 **STEP 2** **STEP 3**

Facial Expressions

THERE ARE SEEMINGLY INFINITE facial expressions you can give your characters, simply by combining the elements we just practiced. In the examples shown, you'll find four distinct facial expressions created for one character, that each imply a different emotion and mood. However, if we were to change just one element on one of the expressions—say the shape of the mouth, for example—we could imply an entirely different emotion for the character.

There is so much to be explored when it comes to characters' facial expressions, and I encourage you to spend some time really practicing this element. For extra practice, sketch out a few different outlines of a head, all identical, and draw a few elements that look the same for each head— maybe that's the mouth, nose, and hair. Now, see what happens when you draw different types of eyes on each one. What does that do to the character's facial expression?

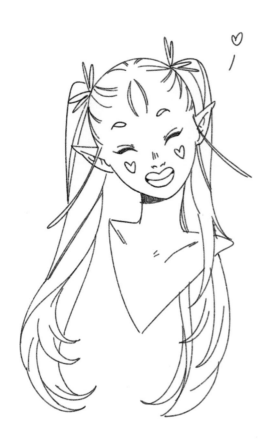
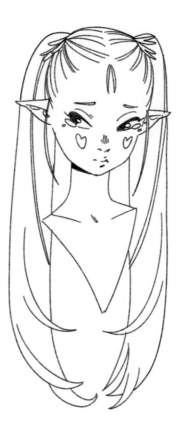

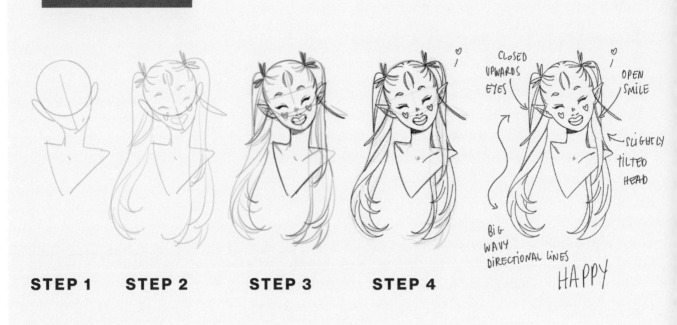

STEP 1 **STEP 2** **STEP 3** **STEP 4**

CLOSED
UPWARDS
EYES

OPEN
SMILE

SLIGHTLY
TILTED
HEAD

BIG
WAVY
DIRECTIONAL LINES

HAPPY

LET'S PRACTICE

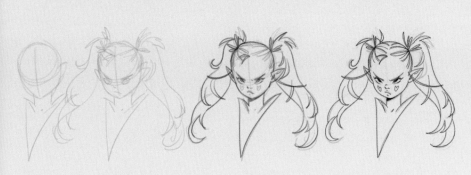

STEP 1 **STEP 2** **STEP 3** **STEP 4**

POINTY HAIR = DANGER

ANGRY

DIRECTIONAL LINES GO UPWARDS

FACE CRUNCHES UP AND TAKES UP A SMALL PART OF THE HEAD

EYES LOOK UP, HEAD DOWN, BROWS ALMOST OBSTRUCT THE EYES

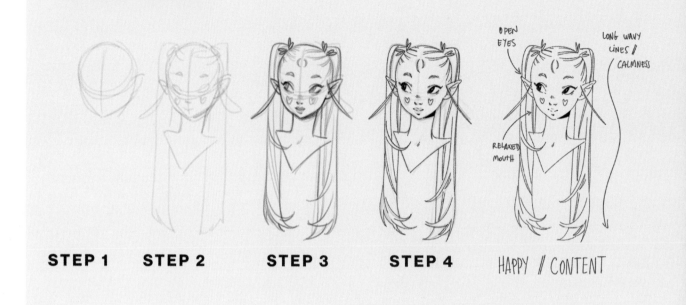

STEP 1 **STEP 2** **STEP 3** **STEP 4**

OPEN EYES

LONG WAVY LINES // CALMNESS

RELAXED MOUTH

HAPPY // CONTENT

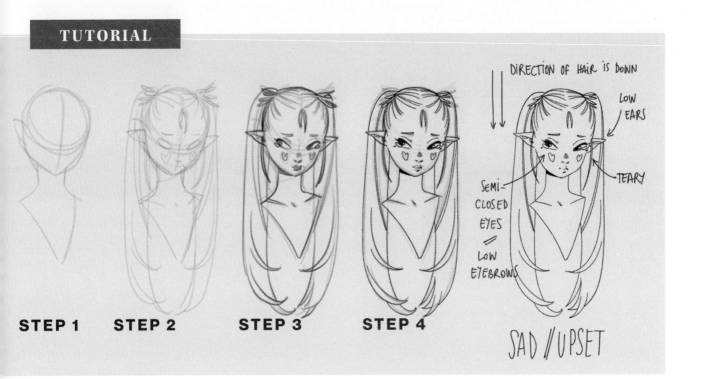

STEP 1 **STEP 2** **STEP 3** **STEP 4**

DIRECTION OF HAIR IS DOWN

LOW EARS

SEMI-CLOSED EYES = LOW EYEBROWS

TEARY

SAD // UPSET

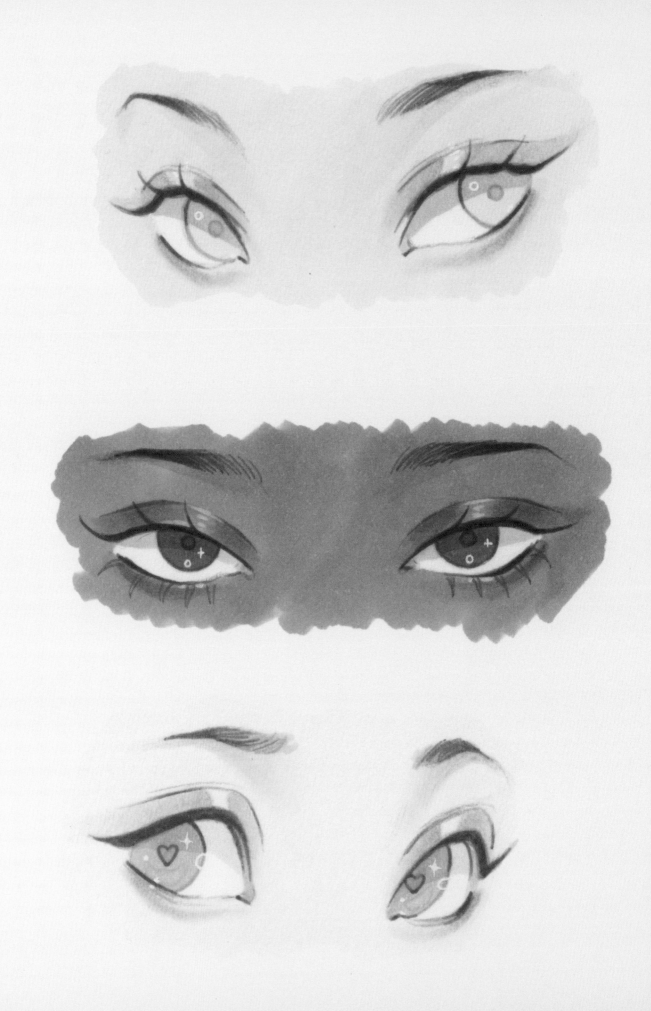

Adding Depth and Dimension

Coloring Techniques for Realistic Characters

NOW IT'S TIME TO BRING IT ALL TOGETHER WITH COLOR.
There are two main methods I follow when adding color: either I add color to a section by first adding a base color, or I add color without a starting base. Adding a base is perfect for when you want to create depth and variety with different layers of color, whereas forgoing a base is fine if you only want one color in a section.

Steps for Adding Color

My painting process always follows the same steps, which makes starting to paint your drawing a lot less intimidating. There are certain things I bear in mind depending on what I am painting, but these are the main steps I follow:

Step One: Make Sure You're 100 Percent Happy with Your Sketch

Once you start laying down your alcohol markers over your sketch, any existing lines will become permanent, and you won't be able to erase the sketch marks anymore. For this reason, I make sure I am happy with every line on the page. Even if some of them look a bit rough and unfinished, I'm usually happy to keep them as long as I feel like they add something to the drawing. Still, it's important to reassess every part of your base sketch before you lay down any color.

Step Two: Add a Base Layer (If Desired)

As I mentioned earlier, you can approach each section of your drawing in one of two ways: add a base color, or don't. Because I love my illustrations to have variety and depth, I usually prefer to add a base layer to each section, but it depends on which area of the illustration I'm working on.

I make sure to add a base color to these elements first, so I can get a good idea of the overall color composition early on in the painting process. For sections that have a designated base color, I sometimes choose the colors prior, while othertimes I like to experiment and go with the flow. Whichever is the case, I try to find a base color that I can use to build up the shadows.

Step Three: Define the Shadow Areas

The next step in this process is to determine where the shadows will go. For this step, I often just go with a second layer of the same marker I used for the base layer. By doing so, I know that the contrast between the base color and the shadow areas will not be too extreme, and I can deepen the shadows wherever needed.

This is a super easy way to map out where you want the shadows to go without the fear of messing up your drawing.

Step Four: Add Deeper Shadows

Once I have determined where the light source comes from and where I want the shadows to be, I choose a marker with a deeper color and create harsher shadows in the areas I feel need more contrast.

Step Five: Add Highlights and Other Small Details

The final step in my coloring process is to add small details. This creates more dimension and interest in the drawing. I mostly focus on adding highlights with my Sakura white gel pen, as well as bits of color with colored pencils. Colored pencils can also be good for adding subtle shadows or gradients, and this is where I would do that.

Some Tips for Specific Areas

WHILE IT'S HELPFUL TO follow these five steps, certain areas of a character can benefit from a slightly different treatment. Note that these exercises have been printed on the practice paper in the back of the book so you can follow along with me!

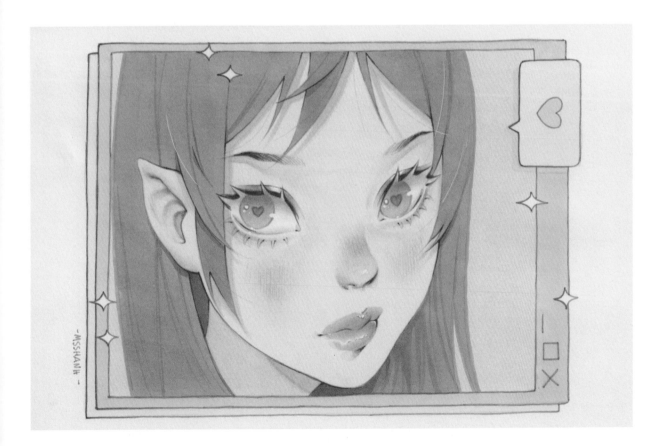

Hair

AS YOU ADD COLOR, always keep in mind the directional lines of the specific hair texture you're working on—just as you would when sketching a character's hair. Doing so helps ensure that the hair looks more natural and flowy, which can really make a difference. Turn to page 90 for a refresher on the directional lines I use for typical hair types.

To avoid streakiness, I like to divide the hair into small strands or sections, focusing on one section at a time. This makes it much easier to lay down a perfect flat and prevents the streaks that can occur when you color in large sections at a time. Starting with the smallest sections of hair can also help you get used to the marker you're working with before you move on to larger areas.

TUTORIAL

STEP 1 **STEP 2** **STEP 3** **STEP 4** **STEP 5** **STEP 6**

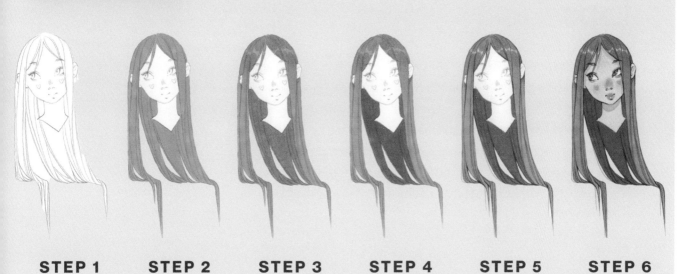

STEP 1 **STEP 2** **STEP 3** **STEP 4** **STEP 5** **STEP 6**

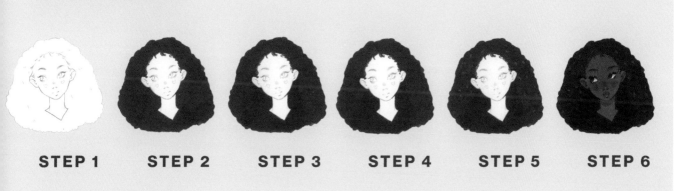

STEP 1 **STEP 2** **STEP 3** **STEP 4** **STEP 5** **STEP 6**

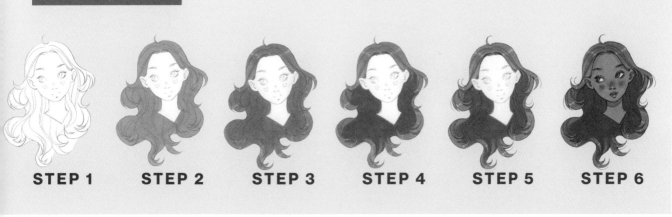

STEP 1 **STEP 2** **STEP 3** **STEP 4** **STEP 5** **STEP 6**

Lips

LIPS CAN BE SURPRISINGLY IMPORTANT in defining a character's personality and style. By first establishing a base shade, you can decide if you want your character's lips to be a natural color or have a tinted shade from lipstick or lip gloss. Next, continue defining the lips by adding some soft shading, which will create depth so the lips appear three-dimensional. Finally, I always like to finish with a touch of gouache to add the appearance of lip gloss, which can provide texture and make the lips look more real.

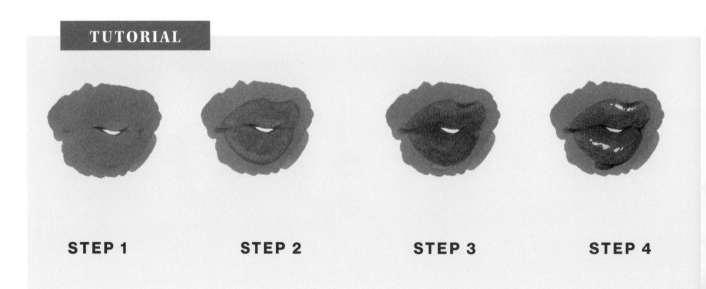

TUTORIAL

STEP 1 **STEP 2** **STEP 3** **STEP 4**

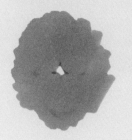 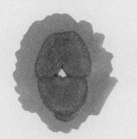 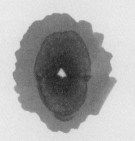

STEP 1 **STEP 2** **STEP 3** **STEP 4**

STEP 1 **STEP 2** **STEP 3** **STEP 4**

STEP 1 **STEP 2** **STEP 3** **STEP 4**

Eyes

THE TRICK TO CREATING beautiful eyes is to aim for a good balance between smooth and harsh edges. I achieve this by focusing on smooth transitions during the early stages of adding color, and then later adding deep shadows and contrasting highlights. By doing this I make sure that the eyes stand out, as these are very important parts of a character's personality and illustrations look better when they pop.

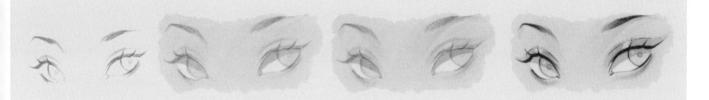

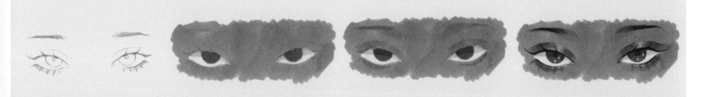

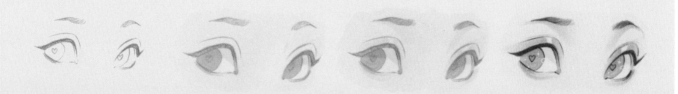

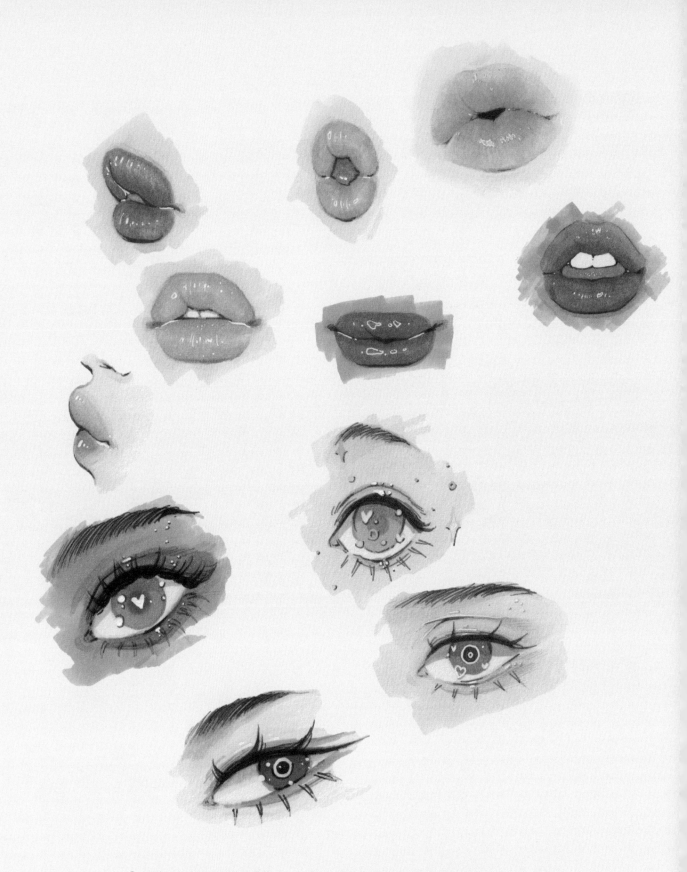

Sometimes when drawing a face, we don't pay attention to each element individually, but instead to the full composition. Whenever you can, it's great to draw individual elements of a face—such as the mouth or eyes—so that you can focus on that element and explore it deeper. You can dig as deep into the details as you like, but this practice lets you explore what resonates with your style and what areas you want to emphasize. This is a good way to gradually develop your personal style.

Face

WHEN COLORING IN YOUR character's face, it's important to create a very smooth and solid base layer. The face is the main part of a character and any streakiness will be very noticeable, so pay special attention to this area.

It can be difficult to achieve fine details with alcohol markers, especially for beginners, so I recommend using colored pencils and fineliners to add detailed areas to the face, from blush and mascara to freckles and scars.

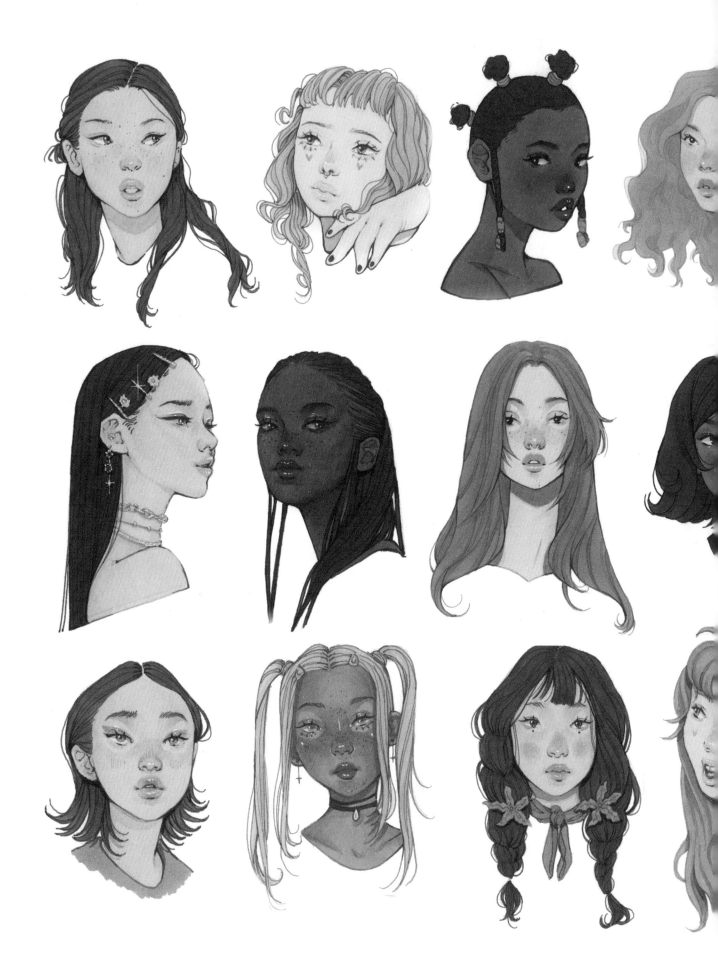

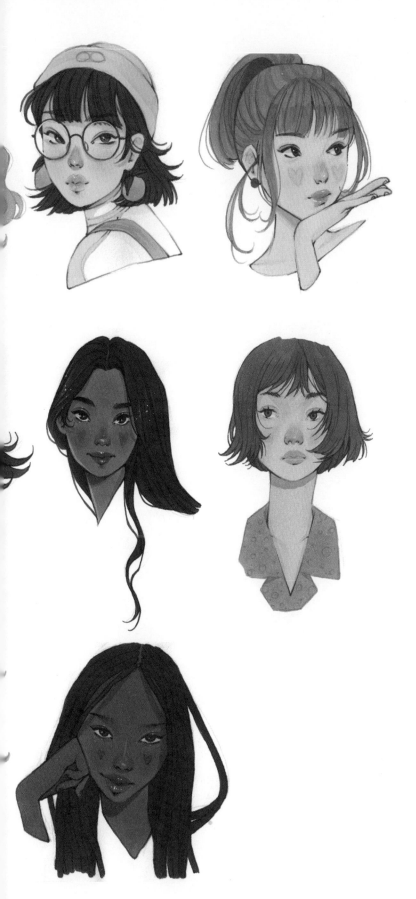

Try to challenge yourself to draw and paint different hair textures and skin tones. As artists, we often gravitate toward drawing subjects or features that we find easier to draw, which can limit our artistic growth. I am guilty of this myself, which is why whenever I can, I try to recreate portraits I find on Google or Pinterest that catch my eye and offer a skill I need practice in. You might not always like the end result, but that can indicate an area to focus your practice on!

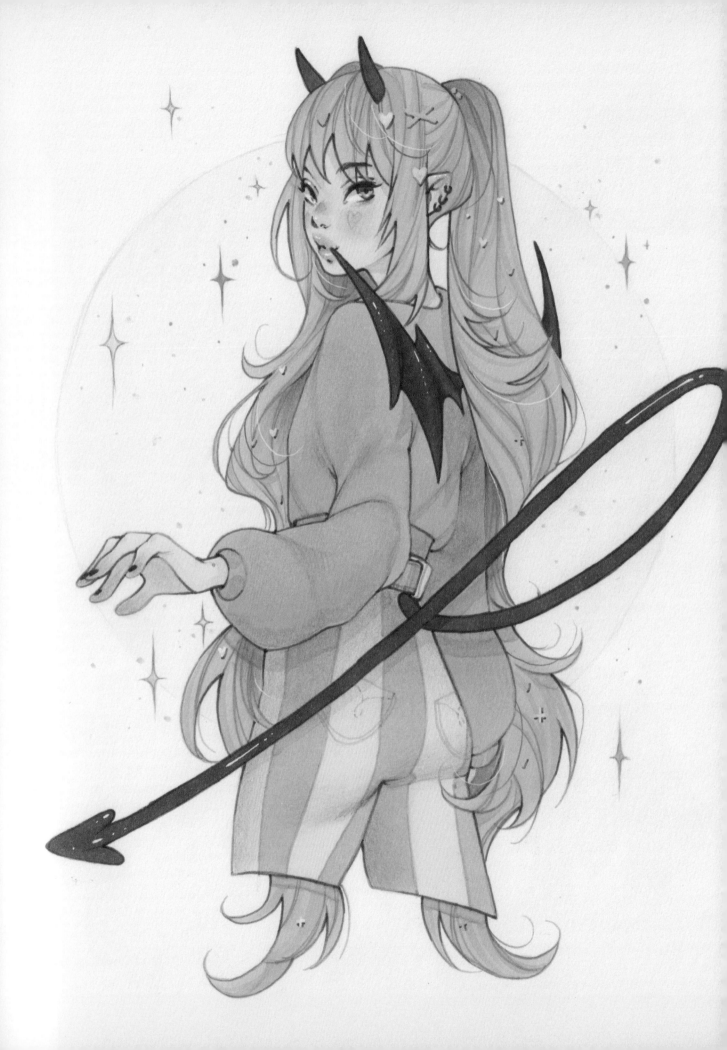

From Sketch to Finished Piece

A Step-by-Step Guide to Creating a Complete Character Illustration

NOW THAT YOU'VE LEARNED THE ELEMENTS OF SKETCHING AND PAINTING A CHARACTER ILLUSTRATION, it's time to bring it all together! Once you read through these steps, grab your sketchbook or flip to this character's practice page in the back of the book and draw along with me as we create an entire character from scratch.

Note: Once you finish painting this character, you'll find three additional character sketches you can use to practice working with your alcohol markers.

Step One: Get a Mood Board Together

To get new ideas and motivation flowing, I always start my projects with a mood board. There are a few places I look for inspiration, but I mainly use Pinterest and Instagram. For this piece, I wanted to emphasize the color pink to bring in some cuteness and a romantic feeling, but I also looked for some playful and youthful images to represent my character.

As you think about what you want from the finished piece, take some time to explore images on Pinterest, Instagram, or anywhere else you find inspiration. Pull them all together in a mood board—whether you make a physical collage or simply create a photo album on your phone—and keep it on hand as you start drawing. You'll likely reference it many times as you work on your character, so make sure it's easily accessible.

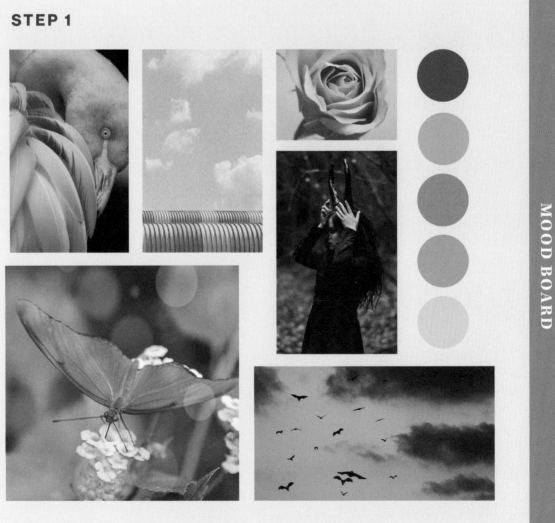

STEP 1

MOOD BOARD

Step Two: Create Thumbnails for Your Base Sketch

Now it's time to put some ideas down on paper. For this step, create a series of thumbnails that are as different from each other as possible, so you can have some variety. (I will sometimes end up blending two thumbnail concepts together!) You don't need to be very precise in this step and can instead focus on the vibe of the piece, the main elements, the personality of the character, and a bit on the composition too.

STEP 2

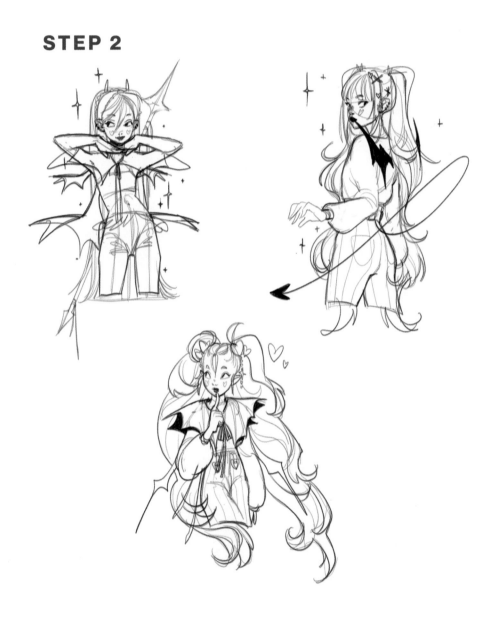

Step Three: Prep Your Initial Sketch

Once you have a series of thumbnails and feel confident with the direction you want to take the illustration, get a new piece of paper and start prepping the sketches for your illustration. This step is where you can also add any details you may have left out in the initial thumbnailing stage. Try to be as precise and detailed as you can, as this will be the main sketch you work with and reference during later stages.

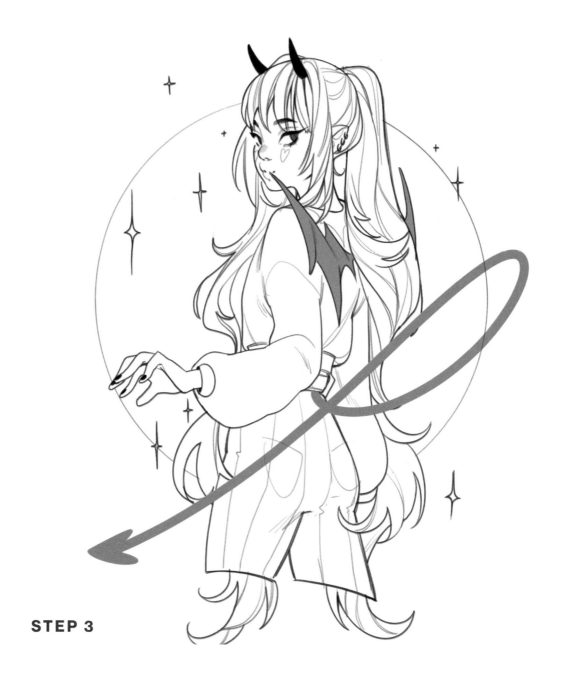

STEP 3

STEP 4

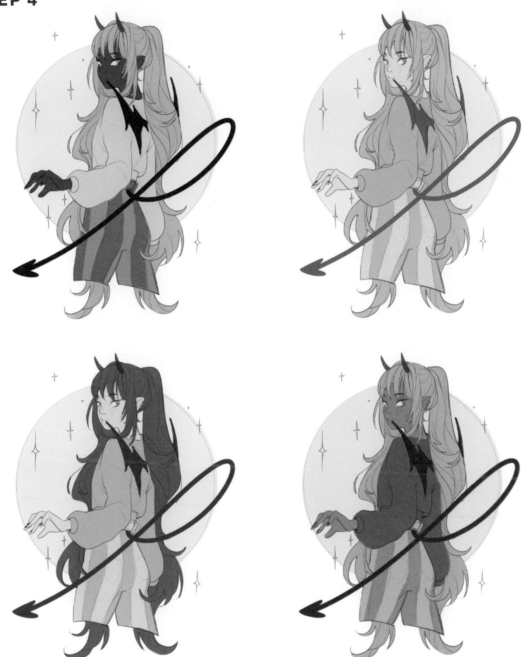

Step Four: Test Out Color Thumbnails

Before painting directly onto your sketch, it's important to first create color thumbnails. During this stage, I typically already know what colors I want to use, but it is super helpful to try different ways of using your chosen color palette. This step also really helps me to be a bit more experimental with my colors.

Step Five: Choose Size and Sizing

It is important that you choose the correct paper size so you don't miss any smaller details that you have on your sketch. It's all about finding a balance between not losing any small details and making sure there aren't any big empty areas that will be difficult to fill in with alcohol markers. For this sketch, I chose an A5 size of paper (approximately 5¾" x 8¼") because I find that that size of paper allows you room to add more complex details to a piece.

Step Six: Fill the Sketch with Flat Colors

Once you know what size paper you want, you can start adding color by filling in the base colors. If you've created your sketches digitally, this is the stage when you should print the sketch. I recommend using a light pad to transfer the sketch onto the paper.

Laying down the base color is a relatively straightforward process, but if you need a refresher on how to create the perfect base and achieve a seamless flat, flip to page 50. During this stage, you'll want to make sure the color is applied consistently and you don't leave any accidental white areas before moving on to the more detailed stages. Adding the base colors can be time-consuming, so I recommend filling in the larger, more important areas first—like the face and hair—before moving on to the smaller, less important sections. Ultimately, however, it's up to you and how you prefer to work.

Above all, make sure you take your time during this stage— I like to take my time to make sure the ink doesn't spread too much and cause streaks. This is a simple step, but being able to apply a perfect base will set up the rest of your drawing for success!

STEP 6

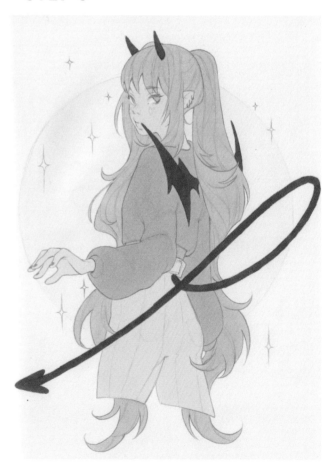

Step Seven: Take the First Pass at Shadows

Once the first layer of color is fully dried out, you can add a second layer of the same base colors. This helps increase the vibrancy of the colors, as well as add some shadows to the piece.

To add shadows, you'll want to grab a darker shade of marker than the base color, but how much darker depends on how much contrast you want. I prefer having well-blended, subtle shadows in my pieces, so I tend to go for just a slightly darker shade than the base color. For more intense shadows, you can go even darker with the shade.

My favorite areas to shade on my characters tend to be around the face and near the hairline, as well as any areas that I want to emphasize, like the tip of the nose, tips of the ears, the lips, and the cheeks.

STEP 7

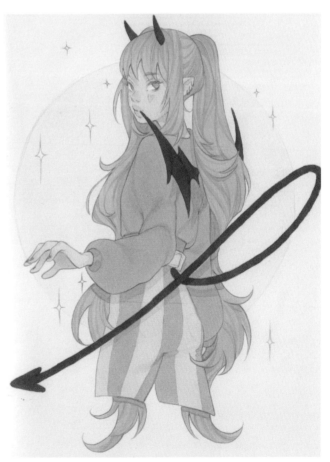

Step Eight: Add Line Art

This is a good stage to start adding the line art. At this point, you should already know what all (or most) of the colors will be, so you will likely have a better understanding of how the piece is coming together. I typically use colored fineliners in different shades to add more dimension to my line art, but flip to page 25 for more information about all the materials I recommend for adding line art.

Remember: When you add line art with colored pencils, make sure to go over the area again with your blending stick so the colored pencils don't leave behind any texture or unwanted streaks.

STEP 8

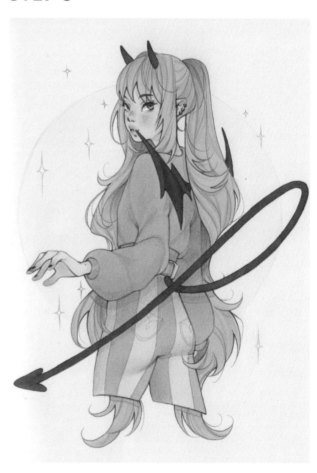

Step Nine: Add Deeper Shadows and Details

This is a step I really enjoy. This is when you can start adding deeper tones to your illustration, as well as more shadows and some other details you may have missed in the previous steps.

Step Ten: Incorporate Other Mediums

Time to add the final details! I'd recommend using gouache or paint pens to add highlights in the eyes and other areas, as well as details in her hair. These mediums allow for lots of precision, so they are perfect for very fine details.

STEPS 9 & 10

PRO TIP

If you're not sure how your darker color (or even just a second layer of your base color) will appear on your base layer, refer back to your swatches. I'd also recommend testing it out by layering the two colors together on a scrap piece of paper. You'd be surprised at how dark some colors can get with just a second layer!

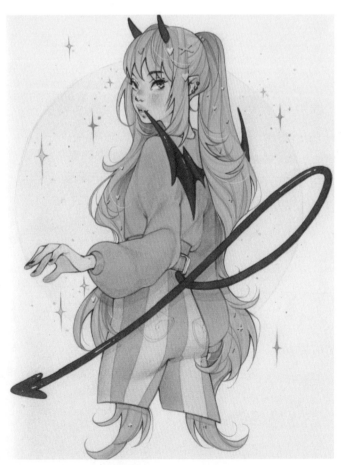

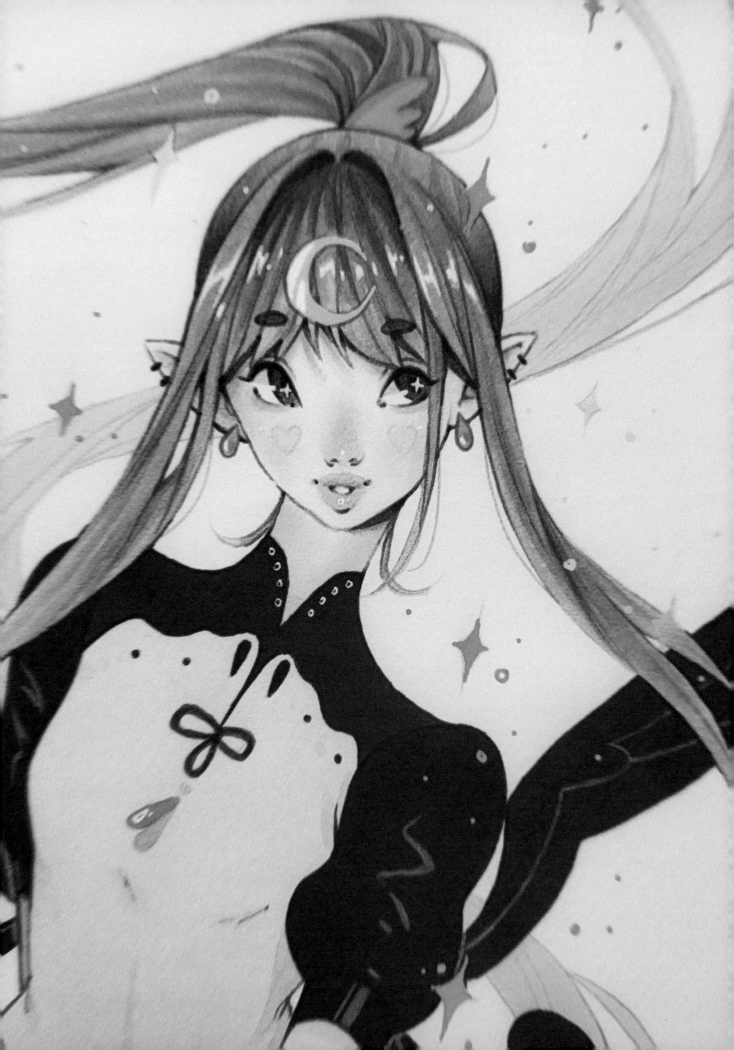

Sharing Your Work

Strategies for Showcasing Your Art and Growing Your Audience

SOCIAL MEDIA HAS BECOME AN ESSENTIAL OUTLET for many artists, a way to share art with the world, at all different experience and talent levels. It is also a great tool to get discovered and find jobs and opportunities in the art field, which traditionally has been a challenging field to break into.

But engaging in social media is not a prerequisite to success, and some artists prefer to try a more traditional approach to art careers. Others may only draw for fun and don't feel the need to share their art with the rest of the world.

But if you are interested in posting online and want to grow an audience, here are some of the steps I recommend for the best results.

Taking Pictures of Your Illustrations

How you take pictures of your art is important, as it can transform the way your art appears online. When I was starting in traditional art, taking pictures of it for social media was one of my biggest struggles, as I found it challenging to take pictures that were good representations. They always differed from how my art looked in person, and it always looked worse in photos. After trying many different approaches, I came up with a method that, in my opinion, works well for alcohol markers.

First, I find that natural light always makes art look better, so take photos in natural light whenever possible. An overcast day usually offers a nice, diffused light that can be the best for art, but I also love the dramatic look of photos captured in direct sunlight.

If you use direct natural light, you don't need a professional quality camera. I have been using my smartphone, and it is always good enough for social media as long as the lighting is quality.

Make sure that your camera is as parallel to the table or surface as possible, as this angle will ensure that you don't get any distortions in your illustration. You should also avoid getting too close to the paper, as this could also produce distortions in the rendering. If you need to fix the composition, an option is to step back and use the zoom function.

Be aware of shadows or other unwanted elements that could distract from the drawing. I like adding little elements like art supplies to add visual interest when I take pictures, but sometimes unwanted shadows or incidentals like pet hairs can make the picture look unprofessional or distracting.

Don't shy away from taking as many pictures as possible, and try different angles!

When the time comes to take pictures, take the opportunity to capture different compositions of your illustrations. By taking close-ups or experimenting with different angles, you can change the perceived composition. Play around with this—you might find something you like!

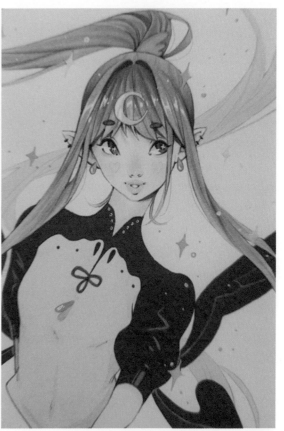

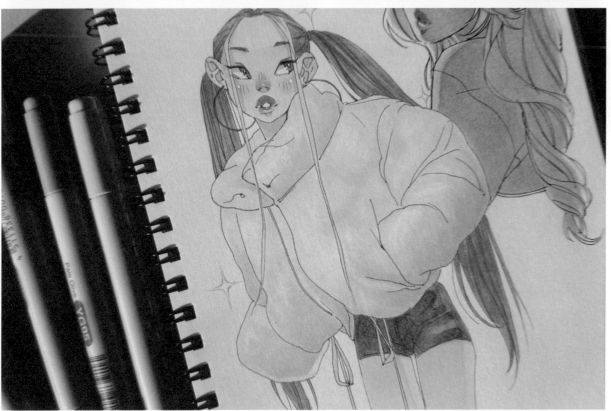

Prepping Photos for Social Media

Once you have your photos, there are a couple of steps I recommend before posting to make sure to give your art the best chance to be seen by more people.

First, before uploading, you can enhance the quality and appearance of a picture by editing it. The colors in pictures usually don't come out looking like they do in real life, but sometimes even if they do, enhancing the colors so they look more vibrant can be more eye-catching. For this, I suggest using an editing app of choice to play around with the settings until you find a look that better represents reality. This is also a great way to keep your online feed looking clean, coherent, and consistent.

Once you are happy with the way the photo looks, pay attention to which platform you plan to upload it to. Apps like Instagram compress images, which is why sometimes photos look different once they have been uploaded: both the color and the sharpness can be compromised by this compression. To minimize this, make sure to edit your photo to be exactly the size that the app requires. The standard sizes change over time, so check every now and then to make sure you have the latest information. Currently, Instagram uses the size 1080 pixels by 1350 pixels, and photos look great when uploaded at that standard size.

PRO TIP

Whenever you upload a finished illustration, don't be afraid to share photos of the work-in-progress stages, the materials that you used, your reference picture, or the artist that inspired that particular piece (just don't forget to tag them!). You can also share any struggles you worked through and the solutions you discovered, which can help other artists learn from those struggles.

This practice will not only be helpful for the community, but it can also promote engagement on your post when people save it for future reference or comment on how much they appreciate the help.

To achieve the rainbow effect in this picture, I used a suncatcher on a sunny day. It's the little things like this that add the extra magic.

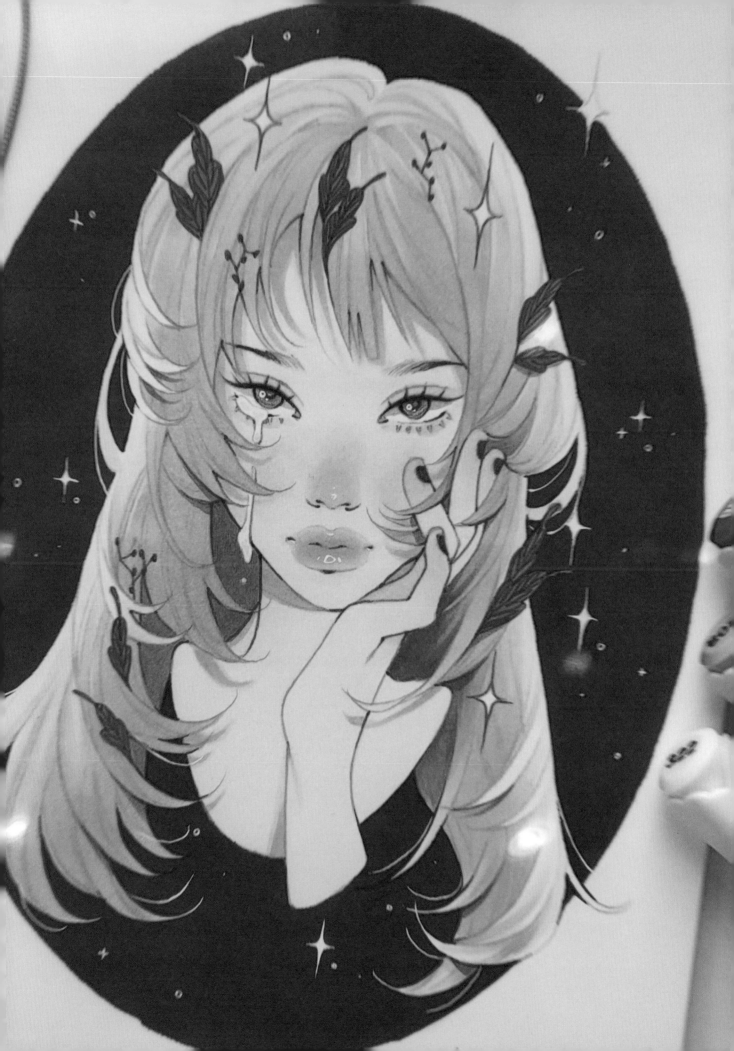

Growing Your Audience

A question that I get asked a lot, both in person and in private messages online, is how I grew my audience to so many followers. This is a difficult question to answer because I think part of it was luck, and every individual artist has a different social media presence. But there are things that can help you reach a bigger audience and have your art enjoyed by more people. It is no secret that having a large online presence as an artist is a great tool if you want to become a full-time artist.

I created my Instagram account after a long hiatus from drawing in hopes that it would push me to draw again. I started from zero and had no presence on other social media. My strategy was to upload as many drawings as possible, and I managed to upload three pieces a week for a couple of months. It was very intense, and I don't recommend this to most people. However, it did work, and it got me my first two thousand followers only after a couple of months. This approach is a great way to get noticed by the algorithm. To maximize the volume of content at your disposal, I recommend reusing some of your work you've already created, as producing three pieces a week burned me out. Try showing some work in progress or process videos to make the most out of every individual drawing.

To figure out what to draw, I followed—and I still follow—loads of prompt lists, challenges, and other events, which offer helpful ways to get inspired and also to get involved in the community. Don't be afraid to comment on other people's pages, or even send them a message or just share and like their work. Being active in the community makes a big difference, and it certainly made an impact on my own success in gaining followers at the beginning, as well as finding some great friends along the way.

Some of my favorite illustrations, like the one you see on the right, didn't perform very well on my social media. At the time I felt discouraged, but now that time has passed, I realize that the things I remember are not the likes or the praise I received online, but the pride and accomplishment I felt after creating something that perfectly portrays my artistic vision.

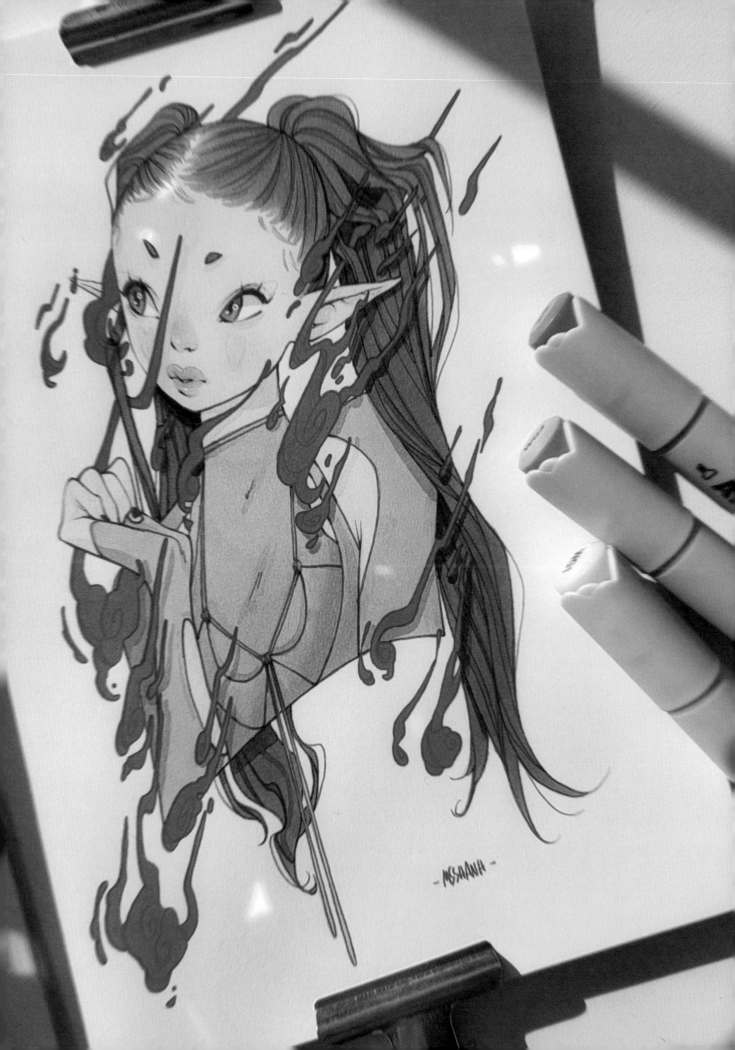

- Post every two to three days, or even more often if you can manage.

- Engage with other artists by liking, commenting on, or even sharing their work with your followers. Often, they will return the favor.

- Take part in challenges like "Draw This in Your Style," "Inktober," and others.

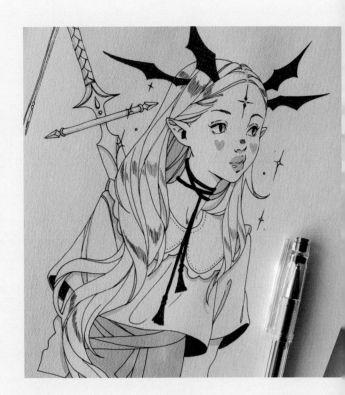

After posting for a few months, I'd learned more about how the platform works, and that was when I optimized my posting to the maximum and started to gain more followers, which ultimately got me to where I am now.

These are the steps I followed once I'd established a small following and had come to understand my audience in a deeper way, and I recommend you employ these tactics if you are working on growing your base of followers:

- Never go more than a week without posting. I realized that going a long time without posting really penalizes you in the algorithm.

- Share your process and sketches. Your followers will love to see bits and pieces of your process, as well as sketches or less refined work that still shows your style. Often, these are just fun!

- Make sure to post at the best time. Check your analytics and only post at your best times—when your followers are most active on social—as it makes a big difference in engagement.

- Use stories often to help your followers get to know you better, so they connect with you as a person, in addition to your art. Don't be afraid to show a bit about your personal life, new supplies that you are trying, or the latest manga series you read. Your followers will really appreciate getting to know the artist behind the art.

- Host your own "Draw This in Your Style" events. Even if you don't think you have enough followers, this is a great way to put yourself out there. I always try to find smaller artists to join their events, and many other bigger artists do this, too. It is a fun experience, and you could be surprised by gaining some new supporters along the way.

- Be mindful of how you caption your posts, using them to share your thoughts and asking questions of your audience. Captions are a great opportunity to engage with your audience, explain more about a piece, or just talk about something you like. Creating a conversation in the comment section will increase the reach of your post.

Lastly, bear in mind that platforms like Instagram and TikTok are ever-changing, and sometimes it can be daunting to try to keep up with algorithms and new features. Sometimes ignoring advice and strategies around optimizing visibility on social media is the way to go if you don't want to compromise your creativity.

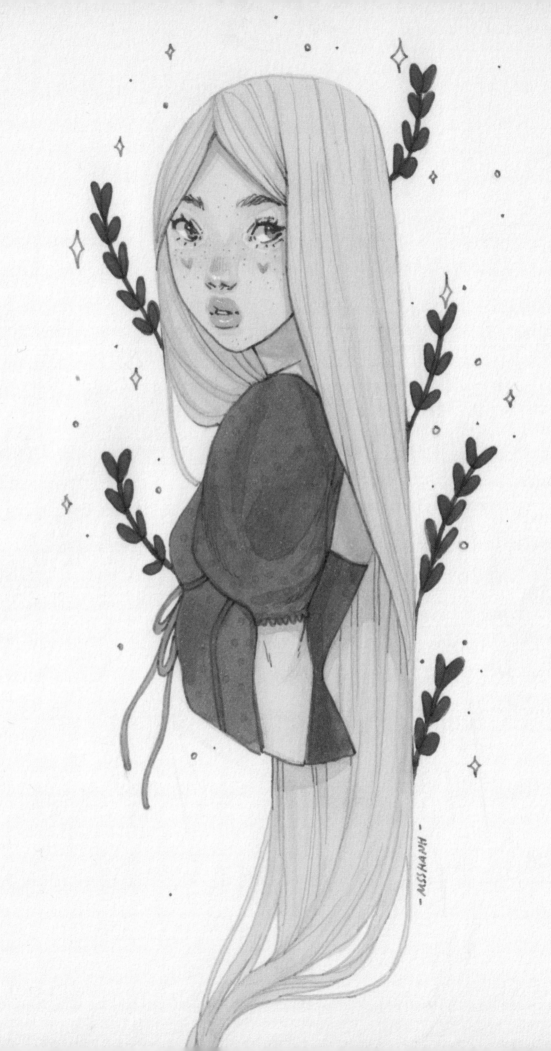

Continuing Your Art Journey

Techniques for Continuous Improvement and Growth

EMBARKING ON AN ARTISTIC JOURNEY can be both exciting and daunting, especially if you're considering making a career out of it. With countless books, videos, and courses available to help improve your art skills, it's essential to find the resources that best suit your learning style and goals.

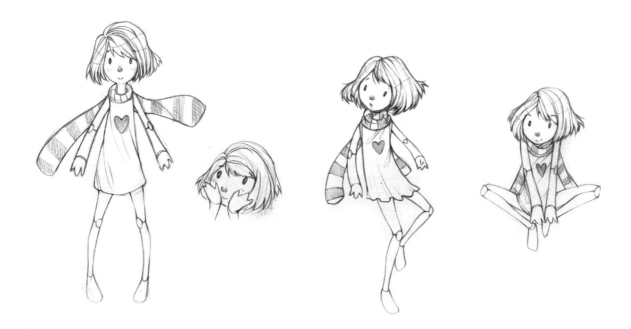

Art School

By the time I had to choose what to do with my future, I knew that art was what I wanted to do as a career, and I was 100 percent sure about it.

However, I didn't find support from my family. There's still a major stigma around pursuing art as a career, mainly because it's not deemed a profitable profession. I think this is a fair concern, but it also comes from the fact that many people, especially from older generations, think that being an artist means selling oil paintings, as if we're in the fifteenth century.

It took me a full year and loads of persuading to finally convince my parents to support my art studies. In the end, they realized that art was my true passion, and it would be worth it to give it a shot.

The full length of my studies took four years, in two different schools. Without a doubt, those four years were the ones I drew the most in my life, even to this day.

My time in art school was crucial for my development as an artist. I improved so much, and a big part of that growth was in thanks to my peers. There's something very special and unique about surrounding ourselves with other artists every day. Every occasion is a chance to sketch something, to show each other what we've been working on, to share new inspirations.

I cherish those years very much, and I try to keep in contact with the friends I made back then, some of whom have become successful comic artists and illustrators.

Despite how fulfilling those years were, there was always an underlying worry haunting our minds: *What would happen when we were done here?*

During art school I let myself try loads of new things, whether it was creating new characters or making up stories and comics. Stepping out of my comfort zone was key to my art development during those years.

Life after Art School

In any field, there's pressure to start working as soon as you finish your studies—to put your degree to use—and art school is no exception. This was particularly hard at the time for me because remote work via the internet had not yet become common or accessible, and I was trapped in countryside Spain, where art jobs were anything but plentiful.

For two years I worked here and there for small local publications, but it was not sustainable. So, I did what every other illustrator does when they need money: I started doing graphic design.

With nothing to lose, I took the four hundred euros I had saved and moved to London to try to find a graphic design job. Luckily, without too much trouble, I found a job as a graphic designer and later moved into the tech industry as an UX/UI designer.

After a long pause in my art, it was then—and only then, when I started having economic stability and didn't have to worry about paying my bills—that I started to draw again. Prior to that, I hadn't drawn much in three years. I'd found that it was too easy to lose inspiration when I had to focus (and worry) about money, jobs, and stability. It had zapped any energy for inspiration right out of me.

Getting back into art was difficult. I'd learned all too well that if you don't use it, you really *do* lose it, and it saddened me to know that I'd lost some of the progress that I'd fought so hard for. But, just as it had been before, the internet was there to give me encouragement, and sharing my art with other artists online gave me all the motivation I needed.

I thought about uploading my work to DeviantArt, like I had back in my school years, but by then artists were already sharing their art and building community on Instagram and Twitter, so I dove into those platforms—a new start!

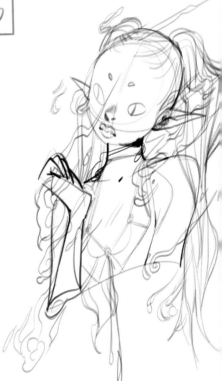

When sketching digitally, illustrations can initially look very messy, but it's important to lay down an idea and add details later.

Self-Education vs. Art School

When I started art school, there weren't many online resources for learning or diving deeper into different crafts, but nowadays there are so many ways to learn online. Even after going to art school, I learned—and I continue to learn—through online resources and books.

Art school often offers something that, in my opinion, is difficult to replicate through self-teaching alone. This is the deep inspiration that you get from your peers and everything you learn from them. Being around fellow illustrators daily was such an enriching experience for me, and my time in art school was crucial for my development as an artist. Every occasion was a chance to sketch something new, to show fellow artists what I'd been working on, to share new inspirations.

Despite that fact, much of the actual art lessons and knowledge I got from my classes, I think I could have gotten from online courses or books just as easily. Also, art school can be prohibitively expensive in some countries, which makes it much harder to access for most aspiring artists. Ultimately, I believe that illustration is a skill that you don't need schooling to learn. So, if you are someone who is currently considering what to do and whether art school is the right direction for you, just know that you can learn outside of the traditional path of art school. Both options are great, and you will learn a lot either way. I've also come to realize that I have never been asked for an art degree for any of the illustration jobs I've been contracted for. A good portfolio is all I've needed.

For those of you who choose the self-taught route, I have two pieces of advice for you, taken from my personal experience. First, never let anyone belittle you for not attending art school—your level of expertise and talent is not measured by your academic titles. Second, try to find a community of artists or illustrators in your area, not just online. You will learn so much from your interactions with them. The lessons you learn from the people you meet, rather than the teachers, can be the ones that truly affect and change you as an artist. Of course, the right teachers can affect you and your trajectory deeply, but the potential to find true inspiration is not confined to traditional schooling.

Recommended Resources

If you do choose to continue on the self-taught path, there are numerous resources that have greatly helped me learn new skills and improve existing ones.

Starting with books, I heavily recommend *Color and Light* by James Gurney. It's a true masterclass in everything color and it's helped me immensely, even if my style is completely different from the author's. James Gurney also has a YouTube channel where he shares more about his process and offers lessons for free. A true gem!

Another book I believe every aspiring artist should read is *Drawing on the Right Side of the Brain* by Betty Edwards. It incorporates the neuroscience of creativity to help you build your foundational drawing skills and discover a new way of approaching your art.

Sometimes there are books that aren't marketed as being "instructional" that can still provide insightful lessons for artists of all levels. This is often the case with books that showcase a specific artist's portfolio, like *The Sketchbook of Loish* and *The Art of Loish* by Lois van Baarle; *The Art of Heikala* by Heikala; *Rêverie* by Sibylline Meynet; and *Expedition Sketchbook* by Laura Brouwers, who's better known as @Cyarine. While some of these artists are digital artists, I truly believe that digital techniques and styles can be transferable to traditional art, so I still consume a lot of digital art.

If you're after inspiration and you like anime-inspired art, I'd recommend the "Visions Illustrators Book" series by pixiv. First published in 2021, a new volume is released each year and features a collection of art from more than one hundred artists. These are some amazing books to have on hand when you need inspiration, but they're also a great resource for learning about new artists and techniques.

If you'd like to learn more about working with alcohol markers, check out the official websites of whichever markers you decide to use for your art. Oftentimes, art tool manufacturers will offer tutorials and guides on their websites that teach best practices. For example, on Copic's website (www. copic.jp/en), they include a "How To" section with articles and videos that cover everything from the basics of using their markers to more advanced techniques. If you're just starting out, I'd highly recommend making use of these free resources.

Finally, I recommend diving into the art community on YouTube and finding artists whose work you love. It's incredible how much you can learn just by observing how another artist works. While there are so many talented artists sharing their processes on the platform, a few that I follow and enjoy include @MINJYE, @CosmicSpectrumArt, @HutaChan, @emhuesart, @AsiaLadowska and @orange_0925.

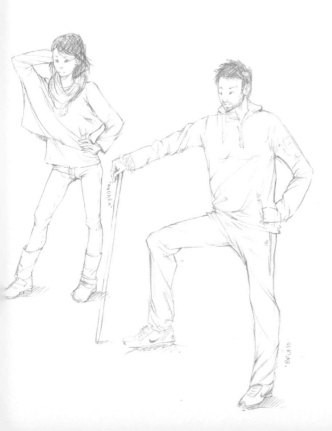

A Final Note

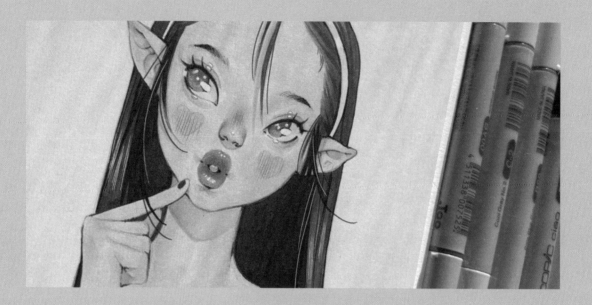

Dear reader,

Thank you for reaching the end of this book. In it I've poured out every bit of information and tips I have learned in my years as an artist, and I hope they bring you inspiration and valuable lessons.

Remember that there are no rights or wrongs in art. I encourage you to try your own ways, to experiment and let loose. Your art is unique and truly yours.

Now that you have the tools, I hope you enjoy creating your art. Please feel free to send me a DM on Instagram; I would love to see what you are creating!

Love,

Lidia

Acknowledgments

I WOULD LIKE TO take the opportunity to thank every person online and offline who has followed my journey as an artist, who has supported me and given me words of encouragement. Being an artist already feels vulnerable enough, but sharing it with the world becomes intimidating. That is why I want to thank all of my supporters from the bottom of my heart—without you, I would have never gotten to where I am, personally and artistically.

I also want to thank my sister, Ana, who has been my number one fan since the first time I showed her a drawing of mine, long before social media. She has endured fourteen-hour workdays for four days straight to help me during COMICON, given me countless ideas, shared every single one of my works with her friends, and hyped me up in times of self-doubt. If I could wish anything for an artist, it is for them to have someone like my sister on their side.

And lastly, I want to thank my peers, who are an endless source of inspiration and support.

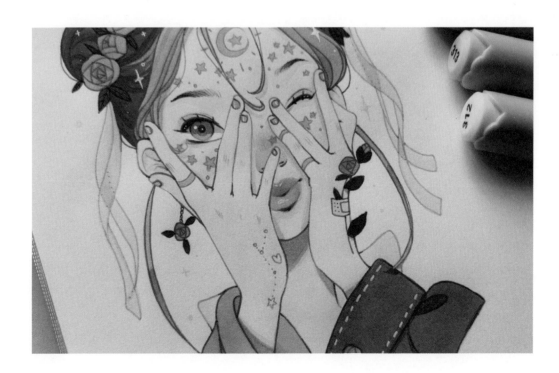

About the Author

AFTER FINISHING ART SCHOOL IN SPAIN, Lidia Cambón (known online as @msshanh) moved to London, UK, and became a freelance illustrator and UX/UI designer.

Having started her art journey at a very young age, Lidia was influenced by the '90s anime broadcast on TV during her childhood, such as Sailor Moon. Her art continued to evolve as different media came into her life, such as video games or the internet, where she could see the work of other artists whom she greatly admired. However, through every phase of her style of drawing remained the influence of Japanese anime and her love for fantasy figures.

Her online presence began when she posted some of her early digital work on DeviantArt, but it wasn't until she came back to traditional art and posted her own approach to the #Inktober challenge on Instagram that she gained a higher level of following.

Since then, Lidia has been alternating between traditional and digital art, introducing new techniques into her work and going outside of her comfort zone, all while staying true to her personal style. She has always been very open about her creativity process, launching several courses and sharing countless work-in-progress videos with her followers so they can see how she works. *Character Drawing with Alcohol Markers* is her first book.

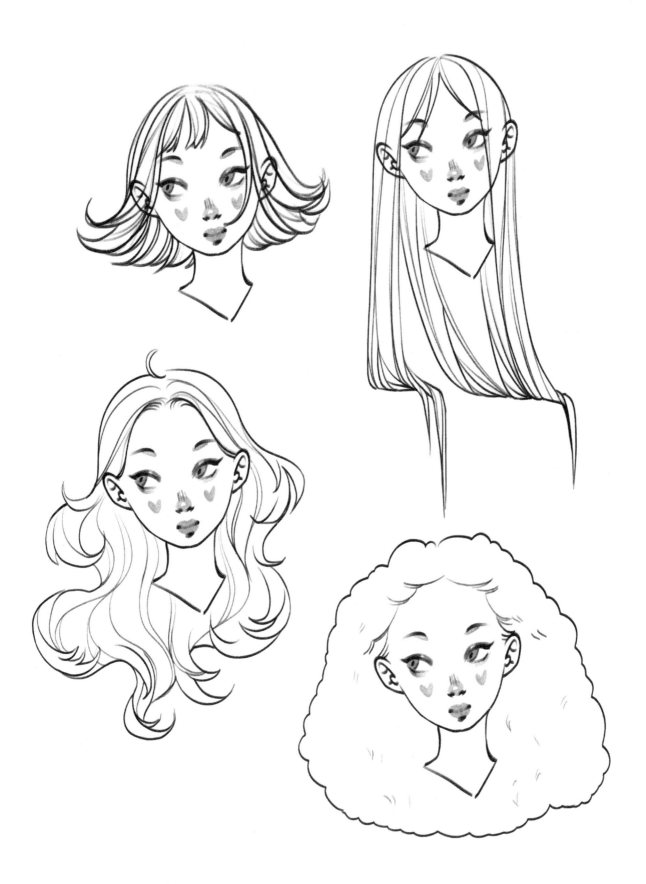

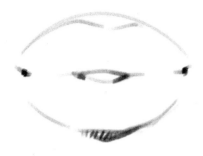

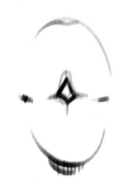

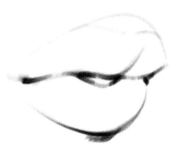

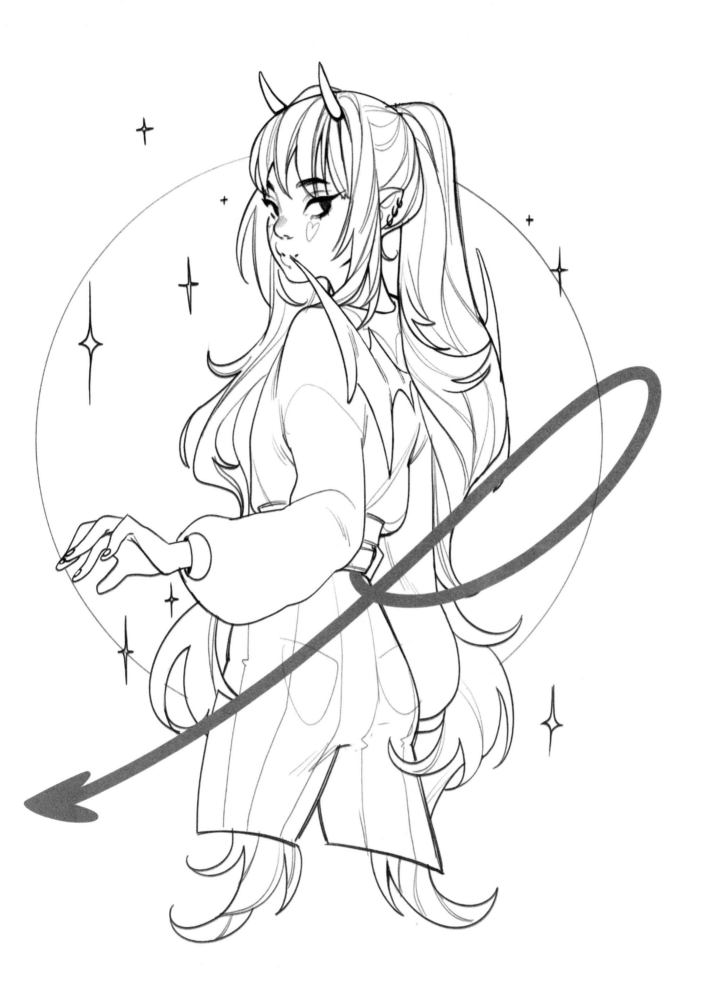

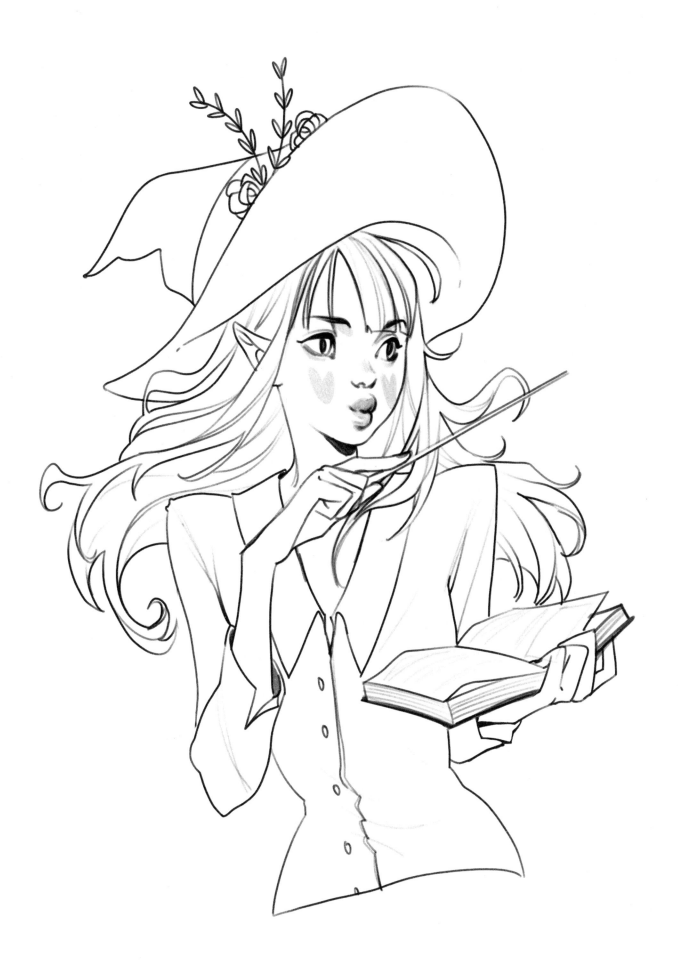

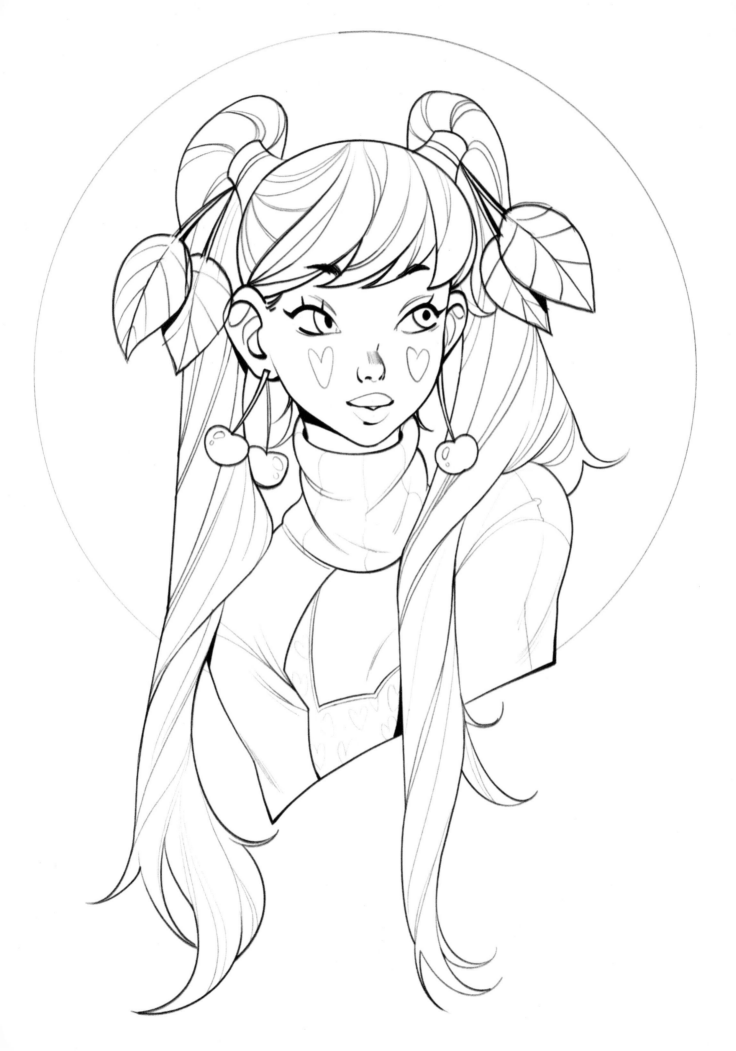